Museums and the
of Disciplines

BLOOMSBURY DEBATES IN ARCHAEOLOGY

Series editor: Richard Hodges

Museums and the Construction of Disciplines

ART AND ARCHAEOLOGY IN NINETEENTH-CENTURY BRITAIN

Christopher Whitehead

B L O O M S B U R Y

LONDON • NEW DELHI • NEW YORK • SYDNEY

Bloomsbury Academic
An imprint of Bloomsbury Publishing Plc

50 Bedford Square 1385 Broadway
London New York
WC1B 3DP NY 10018
UK USA

www.bloomsbury.com

First published in 2009 by Gerald Duckworth & Co. Ltd.

British Library Cataloguing-in-Publication Data
A catalogue record for this book is available from the British Library.

ISBN: PB: 978-0-7156-3508-7
 ePUB: 978-1-4725-2141-5
 ePDF: 978-1-4725-2142-2

Library of Congress Cataloging-in-Publication Data
A catalog record for this book is available from the Library of Congress.

Contents

For my daughter, Sasha

Preface

This book has two converging foci: how museums contribute to the construction of knowledges and disciplinarity; and how, and to what extent, art history and archaeology were differentiated from one another at a key moment in museum history in mid-nineteenth-century Britain.

I became interested in this topic while conducting research for a book on the development of the National Gallery in London in the mid to late nineteenth century (Whitehead 2005a). During a long trawl through the reports of Parliamentary Select Committees, Royal Commissions and other published sources such as Hansard and writings in periodicals and pamphlets, I came across a fascinating debate which took place in the 1850s in which politicians, museum professionals and intellectuals of all kinds thought long and hard about exactly how Britain's growing national collections should be oriented and subdivided, both conceptually and physically.

It became clear from this debate that the distinction between archaeology and art was not at all clear, and the bases upon which bodies of material culture were subdivided and housed in one museum or another were, at the time, elastic and open to thorough re-evaluation. This prompted some interesting questions: why, for example, should Egyptian antiquities or Bronze Age vessels and Renaissance paintings be collected, displayed, considered and studied in institutional and intellectual contexts separate from one another? No convincing rationales for such division were advanced then, and I would argue that none has been advanced since. There were, however, radical arguments in favour of museological strategies

enabling a more inclusive study of material culture, in which works of 'art' and objects of 'antiquity' were not distinguished from one another through the usual means of perceived aesthetic quality.

In the end (and I do not mind giving away the end, for this book is much more about museum processes than it is about museum products), events decided the matter, although this is to put it rather over-simplistically for the sake of brevity (for a more thorough account, see Whitehead 2005a). A number of political and financial factors, none of them especially related to strong intellectual or theoretical positions, led to the consolidation of Britain's national collections in distinct institutions: the British Museum which held 'antiquities' (and, until 1883, natural history specimens), the National Gallery which held paintings only and the South Kensington Museum (known, from 1899, as the Victoria and Albert Museum), which ostensibly concerned itself with 'applied art', although in reality its collections were heterogeneous. I was struck with an alarming sense of how this rather circumstantial consolidation of each museum's respective remit might – along with other factors – have played a role in the placing of boundaries between one discipline and another and, therefore, in the ultimate delimitation of my own range of interests in, and approaches to, material culture, as an individual trained as both an art historian and as an art curator.

The interconnection between museums and disciplines is also not well charted, for the emergence of disciplinarity is more usually associated with the history of universities. But it is arguable that in the 1850s museums were the primary disciplinary drivers as institutions involved in the labour of organising and imparting knowledge through the selection, classification and display of material culture. Here a key issue is the relationship between disciplines and knowledges, which are not the same thing. *Knowledges* are both accounts (for example of the past, and/or of material objects such as sculptures) and ways of accounting, or, to put it another way, modes of representation. Knowledges are not just the *results* of per-

ception, learning and reasoning; they are also processes of perception, learning and reasoning which produce the particularised results. To return to the examples given above, what intellectual structures allow us to account for, to represent, to explain the past and its material remnants? In this respect the knowledges associated with concepts such as 'art' and 'archaeology' (themselves contestable terms) often differed significantly in nineteenth-century Britain, variously involving practices relating to issues of style, context, aesthetic value, iconography, social function and so on. As we will see, to 'know' something as an art object, a product of the history of art, was very different from knowing the same object as an archaeological one, and the distinction involved complex politics of value.

What then constitutes a discipline? We will see various ideas about this played out in the chapters of this book. For now, one might think of it as a core intellectual project shared by a community of practitioners, who are equipped with competencies and knowledges recognised by that community and by outsiders to be appropriate to pursue the said core project – what Christopher Evans, in his examination of the history of archaeology as discipline, has called a 'sense of an accredited or persuasive disciplinary "code"' (2007: 289). In the 1850s art history and archaeology were not established as disciplines in this form, but museum curators and others involved in museum debate were beginning to propose practices in the hope that they might become standard and normative. In this sense one might talk about 'nascent disciplines' or 'proto-disciplines' of art history and archaeology in the mid-nineteenth century, neither one fully detached from antecedent knowledges associated with practices such as dilettantism and antiquarianism. Alternatively, one might propose that disciplines have no identifiable beginnings and are simply constantly developing, dynamic networks of knowledges, communities, institutions and practices, whether such networks are named or not; furthermore, the development of disciplines need not be uniform, and may even be contradictory. I prefer this looser account of disciplines for three reasons. Firstly, it allows me to use the

tools of disciplinary analysis to think about the organisation of knowledge when the term 'discipline' was not much used, but was nevertheless frequently evoked. Secondly, it recognises the fallacy (to which we will return in Chapter 2) that discrete disciplines are unitary, and that universally shared core purposes can be identified, even today when disciplines seem so institutionally entrenched in academia (and of course, recent decades have in fact seen numerous disciplinary 'crises' in which the purposes, roles, practices and scope of individual disciplines have been hotly and publicly debated). Thirdly, it admits of another sense to the term discipline, wherein social and institutional forces within the dynamic network, such as entrenched or new practices of interpretation, classification and display of objects, literally 'discipline' individuals (curators and visitors alike), mostly exclusively, into one knowledge or another.

This book is my attempt to consider these problems at greater length than I have been able to before. It is in two parts.

The first two chapters form an attempt to consider theoretically the ways in which museums are embroiled in the construction of discipline: what particular forms of knowledge and narrative do museums generate and why? This involves thinking about the way in which the museum operates as a medium or set of media, facilitating specific historiographical (political) choices on the part of curators. As Sharon Macdonald puts it, museums 'have acted not simply as the embodiment of theoretical ideas, but also as part of the visualizing technology through which such ideas were formed' (1996: 7). So how does that visualising technology work?

The second chapter moves upwards in its focus, away from the single museum, to consider the ways in which knowledges and disciplines are produced over networks of museums (which need not be formally constituted thus or affiliated in any way), such as, indeed, the publicly-funded museums in mid-nineteenth-century London. The chapter also initiates a drift towards the study of the relations between museums in mid-nineteenth-century London that will become the central focus of the remainder of the book. In thinking about this we might

consider such networks within fields of cultural production, to draw from Bourdieu (1993), or as 'museum worlds', to borrow and appropriate from Becker (1982). What bird's-eye perspectives can we take on the construction and representation of multiple histories and knowledges over multiple sites? How does the cultural cartography of the museum world work as practice (a practice which may be regulated by intellectual, political, incidental and accidental factors)? What 'map' of knowledge can be seen at any one historical moment? Museums are (for the most part) physically bounded institutions. Additionally, their collections and displays are not, and cannot be, infinite in scope; so the organisation of boundaries within and between museums is an important political and epistemological act, undertaken by many actors and regulated by all sorts of circumstances.

Part I adopts and adapts (sometimes considerably) theoretical frameworks which compel me at the moment – in particular aspects of social constructionism, aspects of the works of Howard Becker, of Pierre Bourdieu, of Thomas Gieryn, some (but not all) of the tools from Foucault's tool-box (1974: 523) and aspects of many of the chapters of that seminal volume on the structuring of disciplines in academia, *Knowledges* (Shumway, Sylvan & Messer-Davidow 1993). This is not to deny the possibility of structural or other incompatibilities between these diverse frameworks, the sometimes messy nature of their overlap, or the possible and as-yet unknown benefits of using others. Rather, they afford, I hope, novel and suggestive perspectives on the study of museums and knowledge, and given the readership of this book I will endeavour to make key concepts developed by others comprehensible, obviating as much as possible any need for readers to have to divert their attention elsewhere to understand my arguments. As stated above, one of the metaphors (although as we will see it may not be a metaphor at all) which is used to understand museum representations in the book is that of the map, in which knowledges are grouped together and bounded from one another. I am fully aware that my own approaches are bounded cartographically

by the theories and knowledges with which I choose to play, and in this sense this book is a contingent view of things and not intended as a definitive one (this is not a disclaimer so much as a philosophical position on the writing of history). This is also an appropriate point to declare again my own tribal roots, having trained in art history and then museum studies and *not* in archaeology. This informs the questions I ask and their answers, which concern the interrelated issues of the categorisation of art, its place within discourse and art display. It happens to be the case that in this instance this area of interest involves a significant debate in archaeology as well as in art, which I hope makes this an appropriate, if anomalous, contribution to this series. It must be owned though, that if an archaeologist had written this book it might be very different.

Part II of the book proceeds from the theoretical premises of Part I to focus specifically on the mid-nineteenth-century debate about the interrelated organisation of material culture and knowledge in museums. Chapter 3 examines the discourses surrounding the notions of 'art' and 'archaeology' in museum debate stretching back into the early nineteenth century when key objects such as the Parthenon marbles and Egyptian antiquities were acquired and classified, moving forward to the mid-century. The critical issue here is the use of objects to police, push or undermine boundaries between one knowledge and another. Chapter 4 examines some contrasting proposals for the organisation, classification, siting and definition of material cultures which represent radically different approaches to the structuring of knowledge and the conceptualisation of disciplinarity. Of central importance here was the identification of demarcation criteria which could be used to rationalise divisions between objects and knowledges.

Finally, a brief concluding chapter uses this historical account as a basis for some final thoughts and further questions about the intellectual paradigms in which we work today, and with which we classify practices and material culture either in curricula, in the museum or elsewhere. The point here is that by recognising some of the politics and circumstances through

which the two disciplines were delimited and distinguished from one another we may be able to glimpse (retrospectively) the possibility of alternative art histories and alternative archaeologies. Obviously one cannot proceed from a primary focus on Britain alone to generalisations about archaeology and art history today, which are international disciplines (although it is worth scrutinising their status and consistency as such, as James Elkins has done in his book *Is Art History Global?*). Indeed, the historical account is not intended to be comprehensive (in looking primarily at London it cannot be) and the discussion of intellectual legacies and potentials is not intended to be exhaustive. Rather, both are intended as initial forays into these areas, whereby premises for future study and discussion can be developed.

This is a short book but it would not have come about without the help and support of friends, colleagues and students. Specifically, I acknowledge the encouragement of Peter Stone, who persuaded me that a book like this might be a good idea in the first place, Deborah Blake and Richard Hodges at Duckworth who thought so too, Sam Alberti for numerous pub conversations about social constructionism (among other topics!) and all of the colleagues who, over lunches in the International Centre for Cultural and Heritage Studies at Newcastle University, let me think aloud and then challenged me to think more, and more carefully. Special thanks are due to Catherine Todd for compiling the index. I also need to acknowledge that Chapter 4 is a much expanded version of my chapter in Knell, McLeod and Watson (2007*) and I am grateful to the publisher of that volume – Routledge – for permission to redevelop the chapter for publication in the very different context of this book. Last but not at all least, special thanks go to my good friends Gerard Corsane and Rhiannon Mason, and to my wife, Erica, and my daughters, Alice and Sasha, for bringing me back to myself and to the present, whenever I got stuck in another time.

* C. Whitehead, 'Establishing the manifesto: art histories in the 19th century museum', in S. Knell, S. Macleod and S. Watson (eds), *Museum Revolutions: How Museums Change and Are Changed* (Routledge, 2007) 48-60.

Abbreviations

SCEEC 1816 = *Report from the Select Committee on the Earl of Elgin's Collection of Sculptured Marbles &c.* (House of Commons, 1816).

SCNG 1850 = *Report, Proceedings and Minutes of Evidence of the Select Committee Appointed to Consider the Present Accommodation afforded by the National Gallery; and the Best Mode of Preserving and Exhibiting to the Public, the Works of Art given to the Nation or Purchased by Parliamentary Grants* (House of Commons, 1850).

RCBM 1850 = *Report of the Commissioners Appointed to Inquire into the Constitution and Government of British Museum with Minutes of Evidence* (House of Commons, 1850).

SCNG 1853 = *Report, Proceedings and Minutes of Evidence of the Select Committee Appointed to Inquire into the Management of the National Gallery; also to Consider in what Mode the Collective Monuments of Antiquity and Fine Art Possessed by the Nation may be most Securely Preserved, Judiciously Augmented, and Advantageously Exhibited to the Public* (House of Commons, 1853).

RCNG 1857 = *Report, Proceedings and Minutes of Evidence of the Royal Commission of 1857 on the Site for the National Gallery* (London 1857).

SCBM 1860 = *Report from the Select Committee on the British Museum; Together with the Proceedings of the Committee, Minutes of Evidence and Appendix* (House of Commons, 1860).

List of illustrations

Part I

Museums, Knowledge and Disciplinarity

1

Museums and the construction of knowledge

In this chapter I introduce the discursive nature of the museum, examining the museum as one of the institutional agents which construct knowledge. A good way to begin to do this is to consider the various destabilisations of museum epistemologies which have been played out, whether in the recognition that museum representations are authored, political, culturally located and contestable (this is a key emphasis of the so-called 'New Museology') or by situating museums generally within the context of social constructionism as a historiographical and expository medium (or, more accurately, a technology for the orchestration of different media) which constructs notions of the past and notions such as art and archaeology.

Proceeding from this, we will look at some of the ways in which display operates discursively, for example to produce narratives about the past, to posit relationships between objects and to position the visitor within such representations. What are the ways in which display could be said to communicate, not just through labels, text panels and catalogues, but through architecture, decoration and the articulation of objects in space, among other co-ordinates? If display communicates, then how can we decode or translate its messages? Can we 'read' display as text (in the post-structuralist tradition) or must we also consider display as (in part) a non-linguistic entity? These are important methodological questions, because they make us confront the specificity of museum representations as opposed to others – literature, TV and so on – for which the means of analysis may be more familiar.

Such enquiries form premises for thinking about how theorising takes place in and through the museum – how cultural actions such as collecting, classification, conservation and display are in fact ways of theorising the world, so that museum representations such as collections and displays are, in a sense, embodied theory. Such representations have their own internal dynamics, posing limits and potentials for theorising which allow for the construction of specific theories only; they are, to borrow and warp Bourdieu's famous term, 'structuring structures' which organise expository practice. The stories that museums tell are thus only some among many others competing as truth claims, constructed by various social institutions, each subject to political and logistical pressures which regulate and adulterate their theorisations in various ways. And yet for centuries museums have implicitly claimed for themselves a special authority in this regard, as though the (presumed) authenticity of their material holdings formed a guarantee of the veracity of the stories told through the organisation and presentation of these holdings. This chapter's discussion of knowledge construction and the ways in which theory is embodied and compromised in museum representations will carry through to Chapter 2, where the focus will be on the ways in which the representations of multiple museums can divide knowledges and disciplinary practices.

Museums and social constructionism

The idea that knowledge is socially constructed has been a profoundly influential one over the last four decades. It has had obvious relevance in the fields such as sociology, anthropology and cultural studies in the understanding of situational knowledge structures and the pursuit of cultural relativism. It has been of special importance in the study of education, for example in constructivist theories of learning, and in museology, which, often paying dues to diplomatic, political and ethical factors, has recognised the validity and worth of knowledges which do not relate well to the occidental intellectual assump-

tions that historically underpin the museum. Clear examples of this are the controversies surrounding activities such as the repatriation, and, in the case of human remains, the reburial, of accessioned museum objects; where what is simply a specimen for a museum is, for a given community, a vital and essential part of important cultural and religious mythology which is critically compromised by its appropriation by western museums: in other words, its *musealisation*.

The idea of the social construction of knowledge has also influenced historical and theoretical studies of the development of intellectual disciplines – an area which has been important for some time now, in part because of the apparent emergence and proliferation of 'new' disciplines in universities and the revision and blending of traditional disciplinary knowledges: what the disciplinarity scholar Julie Thompson Klein labels 'blurring, cracking, crossing ... permeation and the fracturing of discipline' (1993). In a quest to understand disciplinarity, 'interdisciplinarity', 'sub-disciplinarity' and even 'oppositional' attitudes to the premises of disciplinarity (ibid.), scholars have argued that just as knowledge is socially constructed, so too are the disciplines which produce and classify it. For example, the Women's Studies scholar Marilyn J. Boxer (2000: 121) states that disciplines were constructed – mostly, in her view, in the later nineteenth century – to codify 'suitable material for learning by the gentlemen, the businessmen, and, especially in Europe, the future state officials and public servants who populated the professors' classes'. Similarly, the educationalist Alison Lee notes:

> Disciplinarity can be understood as a socially constructed, authorised and organised *attitude* to knowledge. Its logic is conceptually a closed logic in terms of its boundary work, constructing grids of specification and exclusion. It is disciplinary logic that has historically mapped onto the territorial and economic units of [university] faculties and departments (2005: 11).

However, one shortcoming of much of this literature is its failure to consider the historical role of institutions outside of the formal education system in the construction of disciplines. In the context of this book this is particularly important for disciplines which involve the focused study of material culture, such as the natural sciences, art history and archaeology and, to some extent, social history and ethnography. 'Natural scientists, archaeologists and art historians,' observes Simon Knell (2007: 7) 'share a similar engagement with objects: they build whole subjects from material things.' For these, a key site for the construction of Alison Lee's 'grids of specification and exclusion' is the museum, and this is especially true of the mid-nineteenth century when universities were less ubiquitous and arguably less central to the social organisation of knowledge. The historian of science Timothy Lenoir, bringing a Foucaultian perspective to the study of the role of university departments in the establishment of disciplinarity, has noted that departments are 'dynamic structures for assembling, channelling, and replicating the social and technical practices essential to the functioning of the political economy and the system of power relations that actualize it'; they are also 'instruments for distributing status' (Lenoir 1993: 72). The museum, it may be argued, functions in a similar way, with the added, important, complication that it also 'assembles', 'channels', manages and exhibits material culture, which is itself implicated in 'social and technical practices' such as collecting, analysis and conservation of objects. Likewise, the museum too is an 'instrument for distributing status' – on the 'expert' staff who work there, upon the material culture itself, and upon the visitors who choose to spend their time engaging with that material culture and with its entrenched disciplinary conventions.

Looking at the museum in relation to knowledge construction can still be edgy work because the cultural stakes are high. For example, the idea that the museum is the primary agent which *constitutes* 'art' – in the sense that its representation of 'art' is *constitutive* and not merely *reflective* (as Stuart Hall (1997) might say) – jeopardises the notion that there *is* a

22

1. Museums and the construction of knowledge

discrete category of material culture and/or experience ('art') which is inherently, essentially and unquestionably special. Nothing, in this view, is art, until it is made so, socially, through a series of political and often institutional acts which attribute meaning and value. As Bourdieu puts it (in a word play on 'knowledge'), 'the work of art is an object which exists as such only by virtue of the (collective) belief which knows and acknowledges it as a work of art' (1993: 35), and artworks are but 'lumps of the physical world to which cultural value is ascribed' (Pearce 1992: 5). The real nature of our 'aesthetic experience' of art is thus also in doubt: seen by some as a quasi-spiritual and occasionally physiological experience (e.g. one that feels 'visceral'), it can instead be viewed as culturally contingent learned behaviour, as decoding (where the code itself is a social construct and not an external 'fact'), as the performance of social ritual, as an act of self-distinction, and so on. If art is a social construct then we may question why it should be seen, studied or experienced differently from, or sited in isolation from, any other mass of knowledge or material.

This is a view of things which, I believe, many would resist, notwithstanding the ongoing effects of the 'cultural turn' upon museum studies and museum practice. For instance, in Haxthausen's 2002 survey of people's perceptions of the relationship between the 'two art histories' (that of academia and that of the museum), one curator lamented the decline in art history graduates' interest in the 'real subject of art', noting that 'fewer and fewer people coming out of university seem to know what a work of art *is*' (Haxthausen, 2002: x, emphasis added), as if art were not 'cultural' but, rather, in some way natural or fundamental, with fixed and universal properties and characteristics. Needless to say, this is a debate which has exercised philosophers for millennia and all attempts to define art as an *essential* quantity, rather than as a socially and institutionally *constructed* one, have proved inadequate. In this sense, as Nigel Warburton states, 'no one has yet come up with a convincing account of what art is' (2003: 118).

In questioning the existence of art like this, the articulation

23

and existence of certain professions, institutions, beliefs and practices which are implicated in the 'construction' of art might also come under threatening scrutiny. The element of threat would be misplaced: just because museums (together with other institutions and agents) construct art and art history, it does not follow that we should reject these constructions in some way as shams, unworthy of our attention. However, it does suggest the possibility of critique and, consequently, revision. Tellingly, with few exceptions art museums have tended to fall short of revision. Where they have engaged in critique – or rather, in the recognition of their own constructional agency – this has been achieved by commissioning temporary installations or interventions by external artists, such as Fred Wilson, whose juxtaposition of objects on display denaturalise the museum act of classification and emphasise its constitutive and political nature. (Possibly the most well known example is his display *Metalwork, 1793-1880*, which juxtaposed slave shackles with finely worked repouseé silver vessels at the 1992 'Mining the Museum' installation at the Maryland Historical Society.) So far, such critique has proved acceptable to museums and commissioning such interventions has been very popular (McClellan 2008: 152). But bought-in critique by artists stands in for more sustained and transparent self-critique on the part of museum workers concerning the responsibilities of knowledge construction, which has yet to happen.

Museums as embodied theory

In what way is the museum's operation theoretical?

Firstly, the museum is an important institutional space for what Bourdieu calls *consecration*, which is the culmination of canonisation (Bourdieu 1993: 123). This means that the museum embodies theories concerning the relative value of objects and the proper ways of apprehending, studying, appreciating or even revering them – of *knowing* them. As repositories of objects perceived to be of historical, aesthetic or scientific value they have (along with other kinds of institution, such as acade-

mies of art) the function of legitimating and reproducing knowledge through identifying objects for study and/or appreciation and according them relative status. In other words, museums present to us what is perceived to be worthy of attention in relation to areas of knowledge associated with concepts such as art, science, history and natural history. The consecration of an object, or, in the case of an art object, of its maker too, is not a snap curatorial decision. Rather, it is the product of what Bourdieu (1993: 81) calls the 'vast operation of *social alchemy* jointly conducted' by agents of all kinds acting over time. The temporal and historical element of this is important, reminding us, for example, that the consecration of the paintings by Raphael is obviously not solely the consequence of their acquisition by museums today, but also of their being commissioned by Popes and other powerful individuals some 500 years ago, and of the slow development of their critical fortunes over time. Through association, however, because it purports to deal in excellence embodied by works such as Raphael's, the art museum may legitimate other objects which were previously accorded less value. 'All forms of recognition,' states Bourdieu, 'are just so many forms of *co-optation*, whose value depends upon the very position of the co-optants in the hierarchy of consecration' (1993: 291 (n. 18)). Museums are positioned high up in this hierarchy.

Secondly, the museum acts as an institutional and spatial site which strongly encourages certain kinds of theorising. The potential of architectural space (including notional space, such as that of buildings which are imagined, planned and yet to be built) to encourage the physical organisation and arrangement of material culture is inherently a discursive one (and, as I will argue later, a sensory one). Display involves the political construction of discourses of all scales and kinds, for argument is embedded (whether implicitly or explicitly) within the placement, juxtaposition and text-, audio- or live-interpretation of objects and within the dialogue between objects, architectural setting and visitor routes. As Sharon Macdonald puts it, any museum or exhibition is 'a theory: a suggested way of seeing

25

the world' (1996: 14). This can be augmented by recognising that museums are not simply reflections or representations of such theories, but enablers of their development, part of the 'visualizing technology' (ibid.: 7) of idea formation. This is because the activity of physically assembling and displaying objects for presentation to publics – indeed even just planning for such activity, as in many of the idealised museological plans of the nineteenth century – is heuristic and structuring. In this sense the theories in question can be emergent rather than pre-defined: they can be worked out through the museological processes of collecting, documentation and display. Thus, curators produce meaning (at least for themselves) through the orchestration of various interrelated media, or, as it might otherwise be said, through the poetics of exhibiting, i.e. 'the practice of producing meaning through the internal ordering and conjugation of the separate but related components of an exhibition or display' (Lidchi 1997: 184). Some of the most commonly recognised components are: the architectural and decorative manipulation of space; the selection, ordering and placing of objects; the appearance and content of text panels, labels or other interpretive materials; the design and placement of furniture, facilities and security; and the curatorial act of imagining visitors. It is now worth examining these in greater detail. (If what follows should lapse into the seemingly obvious or the well-known, I hope it will nevertheless set foundations for more complex discussion.)

The architectural and decorative
manipulation of space

To exemplify this we can consider the various historiographical potentials of different late eighteenth- and nineteenth-century room types in museums, including 'long galleries' allowing for the arrangement of art objects in vast linear series, and 'cabinets' or smaller rooms (each of these types has a longer history than the public museum which appropriated them) allowing for the identification of bounded bodies of objects. In other words,

the articulation of display space can potentialise the construction of different types of narrative. In postmodernity, the narrational aspect of the museum building has been taken to extremes in instances such as the Jewish Museum in Berlin, designed by the architect Daniel Libeskind and officially opened in 2002, where explicit experiential and historiographical narratives are embodied by the building in trajectories and environments such as the 'axes' of Continuity, Emigration and Holocaust, the Holocaust Tower and the Garden of Exile. Such narratives are not merely nominal in their operation. For example, the axis of emigration:

> leads outside to daylight and the Garden of Exile. On the way there, the walls are slightly slanted and close in the further one goes, while the floor is uneven and ascends gradually. A heavy door must be opened before the crucial step can be taken (Jewish Museum Berlin).

Here the architecture emerges as the primary medium of communication and the primary object of experience, subjugating others such as the selection and display of objects (indeed the museum was open to visitors before the objects were put on display for some years, operating discursively through its architecture alone). It is important to note that the Jewish Museum in Berlin is certainly not the first to develop and communicate narrative through the organisation of physical space: it is simply one of the examples in which this potential is both recognised and made explicit to visitors, who are interpellated by the architecture and positioned as subjects, or perhaps cast as actors within a drama. My point is that narration is in the nature of museum architecture – especially new museum architecture – and sophisticated stories can be enacted through it with varying degrees of possibility and openness (of course, the architecture of some museum buildings may also give rise to unintended narratives).

In terms of decoration, the history of museum planning is significantly marked by considerations about appropriate tex-

tures and colours for walls whereby objects might be 'best seen'. The changing standards for texture and colour over time are testament to changing practices of viewing. It is, for example, a commonplace to point out the formal, intellectual and affective contrast of viewing renaissance paintings on traditionally coloured walls of maroon or dark green as opposed to viewing them on the white walls associated with modernist museum display. There is a long tradition of curators worrying about wall colours and textures, from nineteenth-century strictures that wall colour should be 'brighter than [the] darks and darker than [the] lights' of paintings on display (Eastlake 1845: 283) to twentieth-century modernist experiments with the use of beige monk's-cloth as background, as Alfred H. Barr preferred in many displays at the Museum of Modern Art in New York (Staniszewski 2001: 64), or the white or unpainted roughly plastered walls which characterise Carlo Scarpa's famous museum displays from the late 1940s to the 1970s (e.g. the Museo di Castelvecchio in Verona).

Additionally, decoration is explicitly historiographical in nature where it represents or proposes artistic canons by listing consecrated artists' names (a common nineteenth-century practice which survives in more recent instances such as the staircase to the Sainsbury Wing extension of the National Gallery of 1992), or where it seeks to replicate or mimic aspects of the architecture of previous ages and places, perhaps in correspondence with the provenance of objects on display. This latter practice is one of particular centrality in nineteenth-century museum debate, in which various commentators pointed out the importance of contextualising objects on display in some semblance of their 'authentic' contexts, particularly as the act of collecting is inherently an act of wilful dislocation of objects from contexts. This led, for example, to the institution of polychrome decoration at the British Museum by the architect Sidney Smirke, who based his scheme on the latest research into polychromy in antiquity (Whitehead 2005a: ch. 2), and, elsewhere, to extensive historicist schemes, such as in the Neues Museum in Berlin and in the South Kensington

1. Museums and the construction of knowledge

Museum's many Italianate interiors, which often drew inspiration from specific Italian renaissance buildings (Barnes and Whitehead 1999). It is arguable that such forms of historicist architecture and decoration were important precedents in the development of the 'style rooms' developed by the curator Wilhelm von Bode at the Kaiser Friedrich Museum in Berlin in the late nineteenth century and the 'period rooms', intended as more exact reconstructions of historic environments (Gaehtgens 1994: 17), which continue to be used in many museums today. In the period room synchronic representations of specific cultures are developed through historicist (or, sometimes, historical) decoration and the inclusion of various types of object from a given age and place, often arranged to suggest a domestic interior.

The selection, ordering and placing of objects

The selection of objects for display is in no way objective. It is a cultural practice of inclusion and exclusion which responds to, and in turn constructs, contemporary knowledge, organising representations of the past which articulate hierarchical structures such as the artistic canon. Selection also works to identify authoritatively the proper foci of a disciplinary collection, so that with few exceptions the art museum collects 'works of art' in what is usually a very tightly defined (and defining) sense: one or more of the 'fine arts' of sculpture, painting, installation art, video art, along with other associated but less consecrated categories such as 'craft' and 'design'. In general, art museums tend *not* to collect and display historical artistic materials, or the personal effects or human remains of artists and others, such as patrons, who operated within the artistic field at a given time. Archaeology museums, meanwhile, have often collected people's personal effects and remains, but might be unlikely to collect a mediaeval painting. There are interesting examples of art museums breaking the tight definitions to which they usually adhere. The Museum of Modern Art (MoMA) in New York, for example, has a substantial collection of music videos, which forms a heavyweight institutional chal-

lenge to their largely unconsecrated status as products of (mere) popular culture. We will return to this practice, which can be identified as boundary work, in later chapters.

Ordering is homologous with the choosing of sequences and the imposition of serial or other relations between discrete objects. It works alongside placing to construct what Donald Preziosi calls 'anamorphic perspectives' on history:

> from which the history of art may be seen as unfolding, almost magically, before [one's] eyes. The archival mass, in other words, is made accessible from particular prefabricated stances designed to elicit (confer) additional sense from (on) the diachronic and differential system. Common anamorphic perspectives include artistic biography, periodization, stylistic evolution, and the evolution of particular thematic or semantic contents (Preziosi 1993: 223).

Placing also puts discrete objects into physical, formal and aesthetic relation to one another (and in relation to architectural space and decoration) through the notion of the dynamic field of vision, i.e. what the visitor sees with one gaze, and how this changes and diversifies through scanning with the eyes and moving. In this, placing can be considered as a set of articulated and overlapping complex formal compositions in which plays of colour, tone, mass, geometry (or 'directionality' as some designers put it), scale, distance/proximity and value (in particular through lighting and casting shadow) are involved. Such formal and spatial plays may have strong discursive functions, in emphasising (in some cases literally spotlighting) the particular significance, centrality or relations of objects.

The appearance and content of text panels,
labels or other interpretive materials

Written or spoken texts (e.g. labels, audioguides) in museum interpretation are perhaps the most explicitly discursive media, although they are often presented as authoritative or de-

finitive interpretations whose legitimacy brooks no challenge. As many authors have shown (e.g. Bal 1996, Ravelli 2006), forms like text labels are as informed by ideological positions as any other form of historiography. Further interpretive materials such as maps, contextual photographs and TV documentaries in the museum are also cultural products (of course) and are in no way immune to the forms of deconstruction and critique which have been developed in relation to them (Wood 1992; Monmonier 1996; Harley et al. 2002).

The design and placement of furniture,
facilities and security

This a discursive act with different dimensions. Museums contain furniture which separates visitors from objects, contributing to the relative consecration of one object or another. They also may or may not contain seating, thus guiding visitor behaviour and visitors' perceptions about appropriate physical behaviour within museum space. Where there is no seating the museum is harshly differentiated from many other public and domestic spaces, emphasising its distinction and consecrated institutional status within the cultural field. Where seating is provided it may work to consecrate specific objects, by suggesting resting areas which double as viewing areas, and thus as suggested fields of vision comprehending objects which demand (it is suggested) greater attention than others. The visibility of security arrangements – for example bag checking and the presence of identifiable warding staff – also marks the status and worth of collections and literally polices visitor behaviour. Even the existence and accessibility of facilities – cafes, toilets, baby-changing rooms and so on – give a sense of the extent to which museums are prepared to compromise interests in stewardship and storytelling to an interest in visitors' basic needs. Practically, all aspects of the museum are discursive in some way.

The imagining of visitors

This is, for me, the most complicated item on this list. When museum displays are conceptualised and developed, curators (I use the term loosely, for many professional figures are involved in display work) *imagine* visitors with anticipated stocks of knowledge and intellectual and behavioural dispositions (what Bourdieu termed 'cultural capital' and 'habitus') who move through space and engage with objects in prescribed ways. These imagined visitors, it is important to note, may or may not resemble *actual* ones, even where curators base their assumptions on audience research. The imagined visitor has similarities with concepts such as the 'model reader' described by Umberto Eco as 'a model of the possible reader ... supposedly able to deal interpretatively with the expressions in the same way that the author deals generatively with them' (Eco 1981: 7) or Wolfgang Iser's 'implied reader', which 'designates a network of response-inviting structures, which impel the reader to grasp the text' (Iser 1978: 34); but the term 'imagined' describes more accurately for me the curatorial act of calling to mind the physicality of the visitor, both in relation to his or her behaviour and movement through display space. It is the imagined visitor who makes the media of the museum – in particular those directly involved in display – co-operate, who makes sense of the connections and juxtapositions organised by curators, who experiences space and literally travels through the curators' representations of historical time. One might align this to a Barthesian notion of the 'birth' of the reader: as Barthes put it, 'a text's unity lies not in its origin but its destination' (Barthes 1977: 148), but the imagined visitor him or herself is actually curatorially authored. The imagined visitor is the moving, seeing, reading, learning, intellectualising, behaving and feeling element in curators' visions of display spaces. Curators' expectations or hopes as to the social milieu and cultural capital of their visitors inform the stories told through display and how they are told. Visitors in this sense (the curatorial sense) are thus a community imagined from

outside. Needless to say, there is scope for much error here insofar as the imagined visitor may not match real ones, so that the interpretations made by visitors might not be those intended by curators. Or worse, visitors may not be able to decode the curatorial code (perhaps a suggested 'anamorphic position', such as the evolution of style in painting) and may consequently disengage, never to visit again. This is an area of significant current interest in fields such as visitor studies and learning in museums and galleries, where the issue of the co-construction of meaning – how meaning is negotiated between producers (curators) and consumers (visitors) is crucial. An important awareness to draw from this is the often fictional notion of the visitor invoked by curators to allow them to do their work and its limits as a predictive construct. Inevitably, within the complex process of consumption (or reception, as it might otherwise be viewed from within different theoretical orientations), curators lose control of the meanings which visitors make and the experiences which they have in the museum context.

It is through the curatorial and/or accidental orchestration of these components that narratives, messages and discourse are produced. A crude example of narrative is: 'this is how Dutch maritime painting developed in the seventeenth century'. A message might be: 'these two objects relate to each other formally and/or contextually'. Examples of discourse include 'this is art', 'this is the best art', 'this is archaeology', 'these are the most significant archaeological remains'. To illustrate this with a historical example, we might consider nineteenth-century discussions surrounding the display of numismatic collections. The scholar Charles Thomas Newton (whom we will encounter again in Part II of this book) discussed the different statements produced through contrasting ways of displaying coins:

> It will be found that [if] a collection of coins, of which the dates are ascertained, be arranged *chronologically*, their juxtaposition will disclose to us with extraordinary dis-

tinctness the characteristics of the style of successive pe-
riods ... On the other hand, a survey of a large collection
of coins *geographically* arranged, shows us that Hellenic
art was brought to greatest perfection wherever Hellenic
civilisation existed in its fullest intensity [e.g. Sicily], that
it took root wherever that civilisation was planted, grew
with its growth, decayed with its decay (SCNG 1853: 777,
emphasis added).

On this level, it is tempting to see museum representations
as in some way reducible to understandable linguistic state-
ments and analogous with written or spoken language, as the
scholar and curator Robert Storr does (although in the follow-
ing quotation there is a subtext of opposition to the practice of
providing extensive interpretive labels and audioguide tracks):

Now to the basics. The primary means for explaining an
artist's work is to let it reveal itself. Showing *is* telling.
Space is the medium in which ideas are visually phrased.
Installation is both presentation and commentary, docu-
mentation and interpretation. Galleries are paragraphs,
the walls and formal subdivisions of the floors are sen-
tences, clusters of works are clauses, and individual
works, in varying degree, operate as nouns, verbs, adjec-
tives, adverbs and often as more than one of these
functions according to their context (Storr 2006: 23; origi-
nal emphasis).

In an alternative but comparable perspective, Bruce W. Fer-
guson presents exhibitions as 'utterance or utterances in a
chain of signification', whereby they can be considered as the
'speech act of an institution':

And, like a speech act the exhibition finds itself in the
centre of an environment of signifying noises. Less like a
text then, and more like a sound (Ferguson 1996: 183).

1. Museums and the construction of knowledge

Such 'utterances' are made through the organisation of a 'system of representations':

> From its architecture which is always political, to its wall colourings which are always psychologically meaningful, to its labels which are always didactic (even, or especially, in their silences), to its artistic exclusions which are always powerfully ideological and structural in their limited admissions, to its lighting which is always dramatic (and therefore an important aspect of narrativity and the staging of desire), to its security systems which are always a form of social collateral (the choice between guards and video surveillance, for example), to its curatorial premises which are always professionally dogmatic, to its brochures and catalogues and videos which are always literary-specific and pedagogically directional, to its aesthetics which are always historically specific to that site of presentation rather than to an individual artwork's moments of production (ibid.: 179).

Another theorist with a comparable approach is Mieke Bal, whose practice is to ask what is 'written' on the museum walls – written 'not primarily with pen and ink but with hammer and nails':

> Connections between things are syntactical; they produce, so to speak, sentences conveying propositions ... [I] analyze these connections with the help of the fundamental notion that exposition as display is a particular kind of speech act. It is a specific integration of constative speech acts building up a narrative discourse (Bal 1996: 87-8).

Her method of 'reading' display is based on an analysis of her own experience of that display, in relation to 'the architecture of the galleries and the circuit it suggests, the positioning of the works, and the labels providing information on them' (98). This unashamedly and inherently subjective approach (of one gal-

35

lery she notes that 'the colours are pleasant: neither harsh white nor obscuring dark' (ibid.)) tells us a lot about her understanding as an 'informed reader' and her acts of decoding. In some ways, her writing itself curates the curatorship she purports to analyse, in imagining the curators' acts of encoding (and to an extent, imagining the curators themselves). For example, her analysis of the discourses in the display of two nineteenth-century French paintings – Gustave Courbet's *Woman with a Parrot* and Edouard Manet's painting of the same title at the Metropolitan Museum in New York leads her to complex conclusions about emulation and rivalry in the artistic field, maleness, the objectification of women ('so as to achieve the double goal of extolling [their] beauty and excluding [their] participation' (112)) and the *contemporary* curatorial desire to replicate or enact the homosocial order of the past:

> What the captions with these two paintings emphasize in conjunction with the space ... is the narrow, intimate connection between male bonding-in-competition, and this use of women. Thus, the expository discourse revealed to me, largely by means of visual elements working like 'words,' just how important that pecking order is ... Perhaps there is, among the unconscious reasons for the rejection of postmodern historicity based on discontinuity, a desire to stick with the order of the past (112).

Both of these related perspectives – display as analogous to (or homologous with) written text (rather than the wider use of 'text' to signify any attempt to make representation) and display as 'utterance' or 'institutional speech act' – are suggestive and certainly helpful in highlighting acts of authorship which museums have traditionally sought to conceal, and Mason (2007: 26-8) gives an account of other approaches of similar type. But they do not offer convincing and fixed means of analysing *how* discourse is produced in displays, perhaps for good reason – is it really feasible or helpful to analyse the 'grammar', 'syntax' or 'phrasing' of a display? Can the 'speech

act' be translated into plain English? I think not, for too much would be lost in doing so. Is it enough to consider display as 'discourse'? Arguably, we do not have an appropriate language to describe display other than display itself, and no metaphor or analogy fully captures its complexity or accounts for its operation, in part because the experience of display is so profoundly sensual, bodily and kinetic (as *well* as intellectual) as to be beyond mere textual or verbal comprehension. This aligns with current trends in cultural studies which have seen significant critique of the 1960s 'linguistic turn' (a turn in which we are still folded up) whereby 'all human thought and endeavour can be understood as structured by, and analogous to, language' (Howes 2004: 1; see also Classen 1993 and Gosden, Edwards, and Phillips 2006). In this sense it is arguable that the textual approach to the study of display alone (never mind other museum practices) does not capture the meanings made through the interrelations between sense perception (especially complex in the aftermath of the breakdown of the Aristotelian scheme of the five senses), affect and temporal and physical movement through space. Display, understood (not read) in a sensorial sense, is beyond text. We come up against the impossibility of accurately verbalising knowledge apprehended through the senses rather than through analytical processes – a recent preoccupation in museological literature (Chakrabarty 2002; Gregory and Witcomb 2007), and in architectural theories of multisensory experience (Pallasmaa 1996: 28-9).

Another serious issue with reading display is the messiness of the encoding process: given the political and logistical pressures and constraints of exhibition work, we cannot assume that a given display is a perfect expression of the intentions of its producers. As curators well know, 'finished' display can indeed be quite far from one's initial intentions for it, and I will return to this theme very shortly. For Bal, curators employ first-person narrative in museum display, just as an author might in a literary text; but the processes of production differ vastly between book and display, undermining any suggestion that authorship is the same thing for a curator and a novelist

(this is not to say that curators are not authors). These limits to the textual approach are persuasive reasons for not seeking to develop some kind of unified and standardised semiotic system for reading (or indeed for 'writing') display holistically. But they are not sufficient to justify a disavowal of textual understandings *in toto*, and function instead as cautions about laying too much stock in 'readings' of museums, for although museum actions and representations cannot be understood *entirely* through textual analysis, they can be understood partially. The questions to ask then become: what are the authorial characteristics of museum practice and the textual ones of museum representation, and how can they be best analysed? From Chapter 2 onwards I will articulate some answers to these questions, suggesting that museum representations are less like writing or utterances, and more like maps.

Compromised theory

Reviewing the history of museums and disciplines it is easy to find instances in which key theories and methods – often revolutionary ones – have been instantiated through the museological potentials of assembly and exhibition. Consider just three examples: Christian Jürgensen Thomsen's articulation of the 'Three Age' System (i.e. the notion that Bronze, Stone and Iron 'Ages' took place) for classifying human prehistory at the Royal Museum in Copenhagen in the years following 1816 (Heizer 1962: 259; Graslund 1987); the role of museums in the development of comparative anatomy and comparative art history in the nineteenth century through what has been called a systematic 'technology of juxtaposition' (Sutton 2000: 20); and Alfred H. Barr's 1936 genealogical diagram of the development of abstract art, which was potentialised by and implicated within display strategies in the Museum of Modern Art in New York. In summary, it might be argued that to display is to theorise – about the world, the past, about relations between objects and events (Whitehead 2005c), and that theories thus constituted can become disciplinary premises.

38

1. Museums and the construction of knowledge

However, it is important to acknowledge that the theorising which takes place within the actual or virtual context of the museum may be compromised by circumstantial factors which relate to politics and/or logistics. For example, the collecting of art and antiquities for public museums is regulated in part by the economics of the market and by the extent and type of support provided by donors, funders, government and other policy makers. This means that museums are not always able to procure the material culture necessary to constitute a given theory, or indeed that such a theory may never be potentialised or known. Inter-museum politics and relations also mean that individual museums have discrete territories in which they collect in order to avoid overlap with the collections of other museums (an issue to which this book will return in the next chapter). When considering the ways in which external political situations or circumstances influence or permeate museum actions one approach is to locate, as Bourdieu does, the field of culture (in which museums are located) within the field of power; the field of culture is different from the field of power and has relative autonomy (Bourdieu 1993: 45-6; Fyfe 1996: 209), but museums and museum work are in no way isolated from state politics and dominant political ideology. Museums, as Fyfe notes, 'move through social space interpreting, fusing and fissioning as they are caught in the cross cutting pressures of fields' (Fyfe 1996: 210). (We will return to this issue of the extent to which apparently external ideologies can be said to *permeate* the museum and its representations in the next chapter.) On a logistical level, issues of available space, floor-loading capacity, the width of entrances or environmental conditions may all compromise the constitution of theory through display. In short, the museum is a unique site for a unique kind of theorising, but such theorising may well be inherently compromised by circumstance, and indeed, where circumstance is uppermost in the mind of the theorist, theorising may be compromised or delimited *a priori*.

This adds a dimension to understandings of the construction of disciplines which concern themselves with material culture:

these are not only socially constructed, but also museologically constructed. This means that such disciplines involve theories and theorising which are enabled through museological potentials (such as architectural space and display) and practices (such as documentation and classification); but that such actions may be regulated by circumstance. The museum is both a potentialising and limiting force in the construction of discipline and knowledge.

The potentials which the museum involves are themselves prescriptive, for they are based on forms of selectivity (because the museum cannot contain everything), categorisation, narration and value judgment. Categorisation, which is often carried out in the name of documentation, involves the construction of structures for the organisation and differentiation of types according to identifiable (but variable and arbitrary) co-ordinates, such as materials, use, geographical context, shape, age etc. Display involves the identification of: similarities and differences between objects or suites of objects; continuities, genealogies and chronologies; and the importance, prominence and pre-eminence of objects or suites of objects both in themselves and as signifiers of specific histories. Collecting and conservation are also inherently selective activities – one cannot collect everything, and resources forbid the conservation of everything; conservation also involves political choices about what aspects or strata of an object to preserve and restore and how to do so. Finally, the object-centred nature of many museums belies assumptions about the intrinsic and narrative value of *objects* as the most appropriate components of history and the historical record and the most appropriate means of narration. From this brief consideration it is evident that the museological construction of disciplines involves processes and parameters of differentiation (as Alberti (2008: 82) notes, the museum functions as 'engine of difference'), the creation of narrative and the attribution of greater and lesser value to objects, to suites and types of objects, to varieties of human activity and to histories. And of course, these three actions – differentiation, narration and evaluation – are organically in-

terrelated, and together they entail disciplinary premises, practices and discourses. This is not to argue that these actions are exclusively museological; rather that they are at their most explicit in the museum.

Museums and other media

However, the museum is just one of the 'dynamic structures for assembling, channelling, and replicating the social and technical practices' (Lenoir 1993: 72) implicit in the construction of discipline and disciplinarity. It relates closely with others – the university departments already discussed, the interest groups and societies which have a complex historical interconnection with the museum (such as the Literary and Philosophical Societies which flourished in the nineteenth century and gave rise to the establishment of many museums), and other mass-media institutions, such as literature and television. In what ways does the museum relate to these other public institutional structures, and what is its special contribution to disciplinarity?

Other institutions have different *theorising potentials* shaped by their individual properties and the media associated with them. However, each institution may avail itself of another. For example, the learned society in the nineteenth century enabled specific forms of disciplinary construction through the socially specific development, contesting and sharing of data and of intellectual and technical practices associated with the natural sciences, with art, antiquities and so on. Beyond the social confines of the societies themselves, print media were utilised to disseminate ideas, data and evidence of activity, for example in published collections of ancient monuments. Within print 'collections' of this type, a number of theoretical potentials emerge which are unavailable, or make little sense in museum contexts, such as the graphic representation (with varying degrees of 'accuracy' and creativity) and decontextualisation of objects (i.e. from their urban or rural settings to the book-page, with its typographical, ornamental and compositional conventions (Evans 2007: 280)).

Although formally and experientially different, such collections embody interests similar to those of the museum, including assembly, comparison and presentation, and it is not difficult to make the conceptual leap from the Society to the museum. However, there are important differences: printed collections serve not just as works of reference but as rhetorical statements about a given social group (antiquaries, often belonging to localised associations competing for distinction on local, national and international levels) and celebrations of that group's industry, endeavour and cultural capital. The rhetoric of the Society and of its publications is inherently and explicitly social. Conversely, the museum display has been traditionally presented as asocial and inhuman: this is to bolster the authoritative selection, narration and evaluation inherent within it by diminishing the sense of curatorial artifice. The seamlessness of museum display and its ostensible authorlessness help to naturalise the theories it embodies.

Television and literature also contrast with the museum because of their ability to organise narrative through means other than relatively small objects – through the exploration of landscapes, events and the involvement of drama which the viewer or reader will encounter within a controlled temporal frame. In historical literature the museum may be at work within the construction of narrative, but goes unrecognised except perhaps in the acknowledgments; in televised history documentaries, the museum curator or conservator is often enlisted as expert, whose attention to objects will enable the televisual shift between macro- and micro-focus, or between ideas and objects, and who, in being willingly co-opted, authorises and approves the story told by the documentary. As the development of public institutions continues into the digital age, one could argue equally convincingly that there is unique theorising potential in, for example, the internet, or in certain varieties of game engine. In addition, the introduction of digital and audiovisual technologies into the museum environment is increasing – some would say revolutionising – the media potentials of the museum: through the incorporation of televisual

and navigable elements within the museum perhaps the primacy of the object-based narrative will cede ground to others.

However, the special place of the museum in this network of institutions and practices which constitute discipline is, for the moment, that of an apparently authoritative medium for object-centred narratives and value statements, as the principal arbiter of exclusion of categories of material culture from disciplines and the principal steward of boundaries. The role of the museum in promoting human history as one of products (physical objects) rather than of processes (activities, events, trends etc.) has been subject to significant review, for example in publications such as *The Two Art Histories* (Haxthausen 2002) – which examines the current chasm between art history and, in many respects, art theory, as it is practised in the two disciplinary sites of the museum and in the academy – and in policy making, such as the 2001 United Nations Educational and Scientific Committee's (UNESCO) Convention for the safeguarding of the 'oral and intangible heritage of humanity'. In the context of the production of contemporary art the centrality of the object has also been challenged by practices in performance art, time-based art, net-art, ephemeral art and so on, while many artists now work beyond institutional boundaries, producing, for example, urban site-specific interventions which are not amenable to the museum practice of locating art in (or rather *as*) identifiable, collectable and houseable objects (this can be related to Arthur Danto's (1997: 175-92) discussions of 'extra-museal strategy').

Notwithstanding this, museums continue to communicate through and about objects, emphasising to audiences the primary importance of material, material technologies, making and the roles and uses of objects in everyday life. However, as will be shown, traditionally, aspects such as the ownership and use of objects classified as art have been downplayed in art museums, as though such objects were dislocated from everyday human circumstances directly after their creation. In fact, finalised 'creation' itself is a problematic notion, as objects are invariably modified over time as a result of human agency,

such as restoration, and environmental factors, such as decay. But the subjection of the object to processes of change is often ignored or hidden, for it works against the notion that museum objects are, as it were, frozen in time. As 'real' objects (hence the critical importance in museums of attribution, dating and being certain that things are what they are thought to be) which have been 'brought' (captured?) from the past they seem to inhabit both past and present, their physicality representing to us the apparent possibility of contact, or of an 'authentic' connective experience of the past which is truer and more personal than experiences offered by other representations (for example, a film about the Crusades, or about Michelangelo). As Pearce puts it, this is to see 'objects as the past in the present' (2007: 161). It is this perception of authenticity that validates and shores up the museum's authority, its right to tell stories and the unassailable cast of those stories (cf. Pearce 1992: 24-30).

But what happens when stories collide, intersect, fuse or divide; when different museums tell similar, overlapping or conflicting stories? What accidental or orchestrated grand narratives emerge and what pictures of the world and its past are produced? These are questions for the next chapter.

Museum worlds and the bounding of knowledges

Chapter 1 looked at the ways in which museums construct knowledge. This chapter proceeds from this premise to examine how, in so doing, museums divide knowledges (and the practices which generate and become associated with them) from one another. This can be endogenous to individual museums – in the naming and staffing of different departments within the overall organisational structure – and it can be diffused, in the parsing out of material culture (or competition for material culture) between different museums within a given geographical area or affiliation, as well as in the need for museums to differentiate and distinguish themselves from one another. We might ask: what are the knowledge relations between museums which are in geographical, institutional or intellectual proximity? Over the totality of a specific museum 'world', like the 'museum world' in London in the 1850s, what knowledges are produced? 'World' is a suggestive term in this context in that it bears the capacity to pose a link between the inter-museum representation of the world – a world made of continents, seas, creatures (including us), forces and matter – and, in the more vernacular use of the term, the parochial institutional, interpersonal and political relations and contingencies between a given group of museums at a given historical moment.

Museum worlds and world maps

This latter sense moves me to invoke Howard Becker's well known idea of 'art worlds'. An art world is, for Becker, 'the

network of people whose cooperative activity, organized via their joint knowledge of conventional means of doing things, produces the kind of art works that the art world is noted for' (Becker 1982: x). The tautological nature of this definition is intentional, stressing the cultural and social construction of art (ibid.). To make this relevant to museums and disciplinarity some qualifications and substitutions need to be made.

Firstly, it should be allowed that 'people' may or may not have institutional allegiances and interests, so that the people in a museum world are curators, directors, trustees, civil servants (such as Treasury officers), critics, consultants and professional politicians (Becker makes it quite clear that the state 'participates in the network of cooperation' (ibid.: 191)). Secondly, 'cooperative activity' must also admit relatively uncoordinated action. As the South Kensington Museum curator John Charles Robinson put it (albeit rather polemically) in 1892:

> In our museum system everything is in a chaotic state, everything drifts fortuitously; there is no central over-ruling and directive power, no bond of union, and scarcely any intercommunion between one establishment and another (Robinson 1892: 1025).

'Cooperative activity' must also be understood to include contest, negotiation, and disagreement over actions, as well as harmonious work towards some shared goal: it is important to recognise (and the archival record of any museum-centred debate will show this) that the museum world includes actors with different goals who compete to get their way. In this sense we will also think later about Bourdieu's conceptualisation of the cultural field, of which competition is a key feature. Thirdly, and related to this last qualification, the 'conventional means of doing things' are not unified, but form a contested terrain of challenge and re-evaluation informed by the interests of different parties. This is particularly important in nascent or young museum worlds, where conventions and practices are experimental, or based on those of antecedent

institutions with quite different aims. For example, after its founding in 1824, the National Gallery in London initially adopted the management methods characteristic of the private and domestic aristocratic collections familiar to its trustees, until their appropriateness was challenged in government enquiries in the 1850s and a new, bespoke management structure established (Whitehead 2005a: 4). Lastly, museums *are* participants in the networks that 'produce' art works through their representations of art, in their collections, displays and in their visible financial investments in the works of artists (i.e. acquisitions, commissions, residencies); indeed, even natural history museums 'produce' art by seeking to exclude it. But it suits the purpose of this book, which concerns the forcing of distinctions between art and its others (and particularly between 'art works' and 'archaeological objects'), to enlarge this, and to think about the way in which museums produce not art works but *representations*.

So, a translation of Becker's definition might read:

A museum world is a network of people whose cooperative activity, organized via their joint knowledge of conventional means of doing things, produces the kind of representations that the museum world is noted for.

As discussed in the previous chapter, such representations are complex, multimedia narratives relying on historical objects to structure, authenticate and authorise them, and working spatially, visually and textually to situate the visitor within simulations of space and time. This is representation within the individual museum, but how does representation work in a museum world, comprising a number of museums? What map of the world emerges?

In using the concept of the map I am likening the museum's theoretical operation (as discussed in Chapter 1) to the cartographic acts of positing the relations, differences and boundaries between things and between our experiences of things. I am also drawing on an established, if diffuse, tradition

47

which uses the map as a means of understanding cultural action and cultural 'space', most explicitly in Thomas Gieryn's notion of the 'cultural cartography' of science (1999), and proceeding from Shapin and Schaffer's suggestion (also concerning the cultural study of science) that the 'cartographic metaphor is a good one', for it 'reminds us that there are, indeed, abstract cultural boundaries that exist in social space' (1985: 333; see also Silber 1995 for general discussion of the use of spatial metaphors). In studies of the museum, the notion of the map has been used in a related, but different way, in that it is possible to understand the museum-as-map not in a metaphorical sense but in a literal one. Barbara Kirshenblatt-Gimblett, for example, notes that:

> While the museum collection itself is an undrawn map of all the places from which the materials have come, the floor plan, which determines where people walk, also delineates conceptual paths through what becomes a virtual space of travel (1998: 132; see also Whitehead 2006: 20-2)

In this sense, the map is not a metaphor for the museum: the museum *is* a multi-dimensional and multi-media map of the cultural world (and the natural world, in the instance of natural history museums) as produced by curators, with all of the cultural politics which this construction entails: where they went, what they valued and acquired, what they did not, what geographies emerge, and so on. In a similar sense, Robert Lumley notes that museums 'map out geographies of taste and values' and function as a 'means whereby societies represent their relationship to their own history and to that of other cultures' (Lumley 1988: 2). The museum-as-map may be impressively detailed in some areas and ambiguous, hazy or silent in others. Also, it is potentially dual in its representation: it may represent literal geographical areas (the Middle East, Asia, Africa etc.) and/or it may map knowledge and matter, bounding nature from culture, Bronze Age from Stone Age, archaeology from history, art from ethnography, fine art from

applied art, textiles from glass, middle ages from renaissance, and so on. As Gieryn argues:

> Maps do to nongeographical referents what they do to the earth. Boundaries differentiate this thing from that; borders create spaces with occupants homogeneous and generalized in some respect (though they may vary in other ways). Arrangements of spaces define logical relations among sets of things: nested, overlapping, adjacent, separated. Coordinates place things in multidimensional space, making it possible to know the direction and distance between two things. Landmarks and labels call attention to typicalities or aberrations, reduce ambiguities about the precise location of a boundary, highlight differences between spaces of things: they are reality checks, of sorts (1999: 7).

The sum representations of a museum *world* make a map which is gargantuan in complexity and inconsistency: it is not a map that can be scanned with one glance and it may not make much sense because of its internal discrepancies. This is to be expected: it is a map with many authors, not all of whom are attentive to what geographies others have drawn or are drawing, while others fiercely, competitively and territorially overdraw what others have drawn.

A good example of this is the way in which the organisation known from 1857 as the South Kensington Museum (which is the name I will use for purposes of simplicity), which had cast itself as a museum of the 'applied and useful' arts, was bound to justify its inclusion within collections and displays of certain things like sculpture at a time (in the mid-nineteenth-century) when such labelling was under harsh and careful review. Cartographically, the task of the South Kensington Museum was to place something like renaissance architectural or freestanding sculpture as within the same non-geographical 'continent' as metalwork or textiles which were more conventionally seen as 'applied' or 'useful' arts (Levi 2000: 215). The distinction

itself was quite fictional, involving, as it did, a careful avoidance of the ways in which renaissance paintings, housed in the rival institution of the National Gallery, functioned similarly within society, for example as objects of liturgical or congregational use which formed parts of architectural ensembles (within, say, churches). It also involved an avoidance of the fact that other high profile museum worlds in Europe (Paris, for example) placed quite different relations between things like painting, sculpture and applied arts, housing them in one institution. In intellectual terms, the distinction is strained, to put it generously. At issue is the curatorial contest for the right to describe (or rather, inscribe) new territories. What was really at stake were the territorial rights of one museum as opposed to another, and this is more about the self-positioning of museums in relation to others, the competition for resources (objects, collections, histories, visitors, government support in all of its forms, authority) than it is about any desire to be accurate cartographers. Considering the instance of renaissance sculpture, did not the National Gallery or the British Museum have an equal claim to this (constructed) body of material culture? They did have – the desirability of juxtapositions of classical and renaissance sculpture and of renaissance sculpture and coeval paintings was frequently discussed in Select Committee investigations (Whitehead 2005a, chs 4 and 6), so it cannot be said that the South Kensington Museum had an inherent, absolute and exclusive claim. Rather, its staff made a claim more promptly and insistently than anyone else.

In relation to the construction of disciplinary difference we may consider the distribution and collocation of finite objects across finite sites. In other words, the processes by which objects are housed in one museum or another contribute to the construction of disciplinary premises. Networks of individual museums – museum worlds – become Alison Lee's 'grids of specification and exclusion' (see Chapter 1), constituting and differentiating bodies of material culture, attributing different values to them and physically separating them from one another. In this sense it is not just the individual museum which

2. Museum worlds and the bounding of knowledges

is, to refer back to Macdonald, 'a theory' or a 'suggested way of seeing the world', but the sum of museums within a given context, be it municipal, national or international. This is, as it were, *macro-theorising* about what goes where and why.

Again, this form of macro-theorising is compromised by circumstance – for example by the histories, identities, politics, agendas, funding, geographical location and spaciousness of different museums. It is also important to recognise that macro-theorising of this kind involves many actors and therefore much inconsistency in the attribution of values to objects (hence the difficulty of map-reading mentioned earlier), as Kate Hill points out in a study of attitudes to the categorisation of objects in regional museums in the nineteenth century:

> We use different categories, such as 'natural history' or 'fine art', to analyse the shape and development of museums, but those categories could be largely created by the museums themselves ... any category ... is not an absolute division corresponding to a 'real' group in the material world, but rather an imposition on that world created by structures of knowledge. In fact, individual curators had a large measure of freedom in their categorisation of an object as for example, art or archaeology or ethnography, and municipal museums did not all conform to one standard way of dividing objects up. For example, Liverpool Museum regarded some objects as Local History, whereas in Sheffield such artefacts were regarded as either Archaeology or Industrial Art (Hill 2005: 73).

In this sense the premises and content of disciplines can shift and are not automatic objects of consensus. Disciplines are constructed through the interplay of multiple institutions, communities and actors, but their parameters are not explicitly 'agreed upon' or fixed and their practices and content do not cohere into the kind of global systems of knowledge which their status as ostensibly established, autonomous entities would suggest. Here Etienne Wenger's notion of 'communities of prac-

tice' is helpful – and consonant with the notion of the museum world as a 'cooperative network' – in suggesting that collective participation in disciplines leads to the incremental construction and modification of their norms and languages. The discipline is therefore a joint enterprise as understood and continually renegotiated by its adherents, who share 'repertoires' of communal resources (routines, sensibilities, artifacts, vocabularies, protocols, etc.) that have been developed and reviewed over time (Wenger 1999).

Bringing the map into focus

To gain a wider sense of inter-museum mapping, to hold a magnifying glass to a portion of the multi-authored map for a moment, it is worth exploring the example of the contest for mediaeval material culture in the 1850s, although in debate at the time there is a lot of slippage between 'mediaeval' and 'renaissance' when it suited certain individuals' strategic and territorial interests to be ambiguous, as will be seen shortly.

In 1855 the British Museum and the South Kensington Museum both bought mediaeval objects from the sale at Christie, Manson and Woods of the collection of the recently defunct Ralph Bernal, a longstanding Member of Parliament and President of the British Archaeological Association (Wainwright 2002: 3-4 (note 3)). Concerns were subsequently raised about the development of two similarly oriented collections in two separate institutions, as well as the possibility that price inflation at auctions would ensue (SCBM 1860: q. 283). Henry Cole, the Director of the South Kensington Museum, noted that he had always 'scrupulously avoided' acquiring the 'classical antique art' which he understood to be the province of the British Museum (SCBM 1860: q. 2908) (although MacGregor (1997: 25) notes that acquisitions of casts of classical sculptures were considered at South Kensington). But, Cole added, the South Kensington Museum had more claim to 'what is broadly called mediaeval, or renaissance art' because it was 'more practically useful than the art of the Egyptians or, perhaps, the

Greeks and Romans', and thus fell squarely within the remit of the museum (Whitehead 2005a: 79). This easily disprovable generalisation formed a strategic play, and it would be surprising that it went unopposed were it not for the fact that Cole had allies at the British Museum who were strategically interested in limiting the remit of their own institution. The key figure of the Principal Librarian (i.e. the most senior officer) Antonio Panizzi, for example, was opposed to the collection of mediaeval objects at the British Museum (Whitehead 2005a: 76).

The portion of the map which comes into focus here would appear to show a boundary between 'classical' and later material culture. But the cartography produced by the 'cooperative network' of the museum world was more complex than this. When the government granted funds to each museum (£4,000 to the British Museum and £12,000 to the South Kensington Museum) it was to support different orientations which appeared to order the objects acquired by the two museums into different realms of knowledge. Cole's application to the Treasury emphasised the value to the South Kensington Museum of the objects on sale for the:

> suggestions they are calculated to afford for improving manufactures; beauty and excellence of style as decorative works, and for skilful workmanship; as illustrations of technical processes, both from a scientific and artistic point of view; and lastly for their interest as historic specimens of manufacture and ornament (Wilson 1985: 73-7 (note 96)).

While for the British Museum importance was attached to different criteria:

> [the museum should purchase] such objects as are not only good of their kind, but which have on them a date, the name of the artist or some interesting historical association. They are in fact a collection of documents on the several branches of art to which they belong (ibid.).

This distinction maps objects not in relation to time (e.g. the chronological constructs of classical and post-classical) but in relation to use. On the one hand, the South Kensington Museum apparently sought objects which could be both exemplars for imitation and 'specimens' within the taxonomic order; on the other, the British Museum appeared to seek objects as documents which were, if possible, evidentially linked to the time and place of their creation. It should be clear that this distinction, or boundary, is a fragile one, for the same objects might well fit both categories very closely. For example, a thirteenth-century Spanish spice box (Fig. 1), thought in 1855 to be a Christian reliquary, was acquired in the Bernal sale for the South Kensington Museum and could correspond to the museum's intention to seek taxonomic 'specimens', although with its relatively basic construction it might be seen to correspond less well to some of the other criteria relating to skilful workmanship, beauty and excellence of style. However, at the same time, as a (presumed) reliquary, it could equally have been of interest to the British Museum for its 'historical association', in its role as a document of Christian practices and as a sometime container of an object invested with, or seen to bear, particular religious significance. The V&A Museum website now states that the 'spice box is the first piece of Jewish art to be bought by the V&A for its collection' (V&A 2008), grounding its status as 'piece' and seeking to stabilise its meaning. Notably in the later acquisition of the Soulages collection of Italian and French renaissance objects in 1856 the South Kensington Museum adhered to one criterion which closely resembled the British Museum's insistence on 'historical association', for the officers recommending the purchase (John Webb and John Charles Robinson) emphasised the value of the objects not only as works of art, but also because many of them had belonged to people of historical note (Davies 1998: 179). This tells us something about the lightness with which lines can be drawn on the map!

Some commentators clearly did not believe in the boundary established between the British Museum and the South

Kensington Museum. The South Kensington curator J.C. Robinson, for example, noted that by allocating purchase funds for the Bernal collection to each museum:

> the state virtually committed itself to the formation of two concurrent new undertakings of the same character, collections destined to be separately housed and developed, with little co-operation between the managers of the separate establishments, if not indeed with tacit rivalry betwixt them (Robinson 1897: 956; also quoted in MacGregor 1997: 25)

Others thought that the mapping effected through the parsing out of acquisitions between the two museums had literally misplaced objects. The antiquarian Albert Way wrote privately to the British Museum curator A.W. Franks:

This Bernal affair must have been as prejudicial to yourself as I am sure it has been to the real interests of the students & lovers of National Archaeology, who must have patience still & be content to find at the Brit. Mus. fine things which they don't want, & [which] have no business there, whilst their healthy appetite remains unsatisfied (quoted in MacGregor 1997: 33 (note 97)).

For Way, 'fine things' (which, we might infer, have pre-eminently artistic properties) do not belong in the British Museum, seen as a realm of historical, and not artistic, knowledge. The experience of Way's imagined visitors ('students & lovers of National Archaeology') is dislocated by the intrusion of new codes. These are activated through the inevitable assertion of the aesthetic values of 'fine things' and the consequent setting up of a 'response-inviting structure' (Iser 1978: 34), prompting visitors to engage in aesthetic 'appreciation' (not 'study'). The imagined visitor's reading of the map is confused by landmarks alien to the terrains of historical understanding and connection with the past, and the *usefulness* of the map is compromised. This is a key issue, for as Becker points out, the value of representations lies not in their accuracy, but in their use (Becker 1986: 121, 125); Gieryn paraphrases:

Questions about accuracy – that is, a map's mimetic fidelity to the places it represents – can be answered only in terms of pragmatic utility. Seismologists need a different map of San Francisco than do tourists, drivers, pilots, market researchers – all of whose maps may be accurate as well as profoundly different (1999: 11).

There is an extent to which the cartographical act of the museum world's combined representations is a matter of competition and opportunist strategy, for example when actors like Henry Cole pushed boundaries and extended collecting policies when acquisition opportunities arose. A form of inverse colonisation of objects and knowledges comes about, as museums lay

claim to sequester them and bound them within their own walls – to fix their locations on the map in an attempt to stabilise their status, meanings and use as one thing or another, as art or archaeology. Thompson-Klein points out that 'boundaries are not simply lines on a map'; she proceeds, quoting Tony Becher and Paul Trowel:

> rather 'they denote territorial possessions that can be encroached upon, colonized and reallocated. Some are so strongly defended as to be virtually impenetrable; others are weakly guarded and open to incoming or outgoing traffic' (Becher and Trowel 1989: 38; Thompson-Klein 1993: 186).

Gieryn emphasises the profitability of drawing (and redrawing) maps, for producers 'have a stake in the seizure or defense of epistemic authority', and can adjust meanings to pursue that stake (1999: 15 (note 18)). In this context he invokes Foucault's interest in the spatialised representation of knowledge:

> The formation of discourses and the genealogy of knowledge need to be analyzed, not in terms of types of consciousness, modes of perception and forms of ideology, but in terms of tactics and strategies of power ... deployed through ... demarcations, control of territories and organizations of domains (Foucault 1980: 70-1, 79, quoted in Gieryn 1999: 20 (note 25).

Gieryn also makes the important link between strategic or competitive cartography and the domains it delineates. In other words, the exercise of power has consequences which bear on the division of knowledges, and may, for example, subjugate objects exclusively into specific taxonomies and interpretive regimes:

> Ordinary folks seek out cultural maps to locate credibility; fact makers produce maps to place their claims in a

territory of legitimacy – but such cultural cartography also has consequences for the spaces mapped out (14).

In this context – that of the power play – the South Kensington Museum would seem to be one of the most aggressive actors within the museum world of mid-nineteenth-century London. I have written elsewhere (Whitehead 2005a: 166-71) about the introduction of easel paintings into the museum's collections and displays and the clear threat which this posed to the rival institution of the National Gallery. This was a strategic and concerted endeavour on the part of key South Kensington Museum personnel to reduce the sphere of influence and delimit the remit of the National Gallery, which would, in the curator Richard Redgrave's view, be best recast as a '*Salon Carré*, a tribune for our choicest treasures' with an ahistorical and aestheticising display in which paintings perceived to be the best could be hung decoratively and without reference to chronology or provenance. Meanwhile, the South Kensington Museum would seize the authority to survey painting historiographically (Whitehead 2005a: 166). Cole went so far as to write an anonymous pamphlet making the same suggestion (Cole 1857), and his staff made similar arguments in print. The introduction of easel paintings was difficult to reconcile with the stated commitment of the South Kensington Museum to ornamental and applied art and museum officers did not much try to do so. When asked what the scope of the museum was in a Select Committee investigation in 1860, Henry Cole stated that it 'primarily accommodates the collections of ornamental art', but that a secondary function (although there was no government mandate to speak of for this) was to accommodate 'collections which have been destitute of any space found for them by the public' (SCBM 1860: 2905), allowing himself significant room for strategic manoeuvre. But the flexibility, adaptability and resourcefulness of the museum's officers and their speed of action – for example in hastily constructing new galleries when opportunities to lay claim to paintings arose – worked to increase the museum's visibility, influence and claim to public

and government support (Whitehead 2005a: 168). This area of the map bounds the best art from the history of art. As J.C. Robinson put it in 1892, the 'bounds of jurisdiction of the several provinces of these institutions [i.e. the national museums in London] overlap in all directions, and their respective interests clash' (Robinson 1892: 1025); but of course this does not mean that the map does not get drawn – it simply makes it more complex and arduous to interpret.

However, the cartographical act of the museum world's combined representations is not organised through competition alone. Returning to the parsing out of post-classical material culture between the British Museum and the South Kensington Museum it is possible to identify instances of collaboration which define borders as strongly as did competitive actions. In 1853, the highly influential and well-connected Antonio Panizzi, then Keeper of Printed Books at the British Museum Library, suggested that Henry Cole acquire the Gherardini collection of renaissance sculpture (which contained original works by Michelangelo) for the Museum of Manufactures – a precursor of the South Kensington Museum (Davies 1998: 174). In so doing, Panizzi was ceding an important claim to such material and setting a precedent. Panizzi and Cole seem to have agreed broadly on what should go where (Wilson 2002: 130, 141), but elsewhere Cole had to force the issue; in seeking government funds for the acquisition of the Gherardini collection Cole noted the statement made by the President of the Board of Trade, Edward Cardell, that the works of Michelangelo had no place within the Museum of Manufactures (Davies 1998: 174). Cole successfully raised funds nevertheless, warping the connotations of the 'ornamental arts' and even 'manufacture' without competition from other museums.

Another similarly illuminating incident took place in 1858, when A.W. Franks of the British Museum made a representation to the Board of Trustees to release funds for the acquisition of the figured Anglo-Saxon box now known as the 'Franks Casket' (Fig. 2):

Previous to my last visit to Paris my attention was di-
rected by Mr. [John Charles] Robinson the curator of the
South Kensington Museum to some carvings in the hands
of a dealer in Paris which he thought might prove desir-
able acquisitions for the [British] Museum. The carvings
were said to be inscribed with Scandinavian Runes but on
examining them I saw that they were far more interesting
as the Runes were evidently Anglo-Saxon (quoted in Cay-
gill 1997: 161).

What is notable here is, of course, the sharing of intelligence
between curators at different institutions, in which is also
implied a sense of who has (or should have) claim to what. We
can only guess why Robinson chose to forego any attempt to
secure the Franks Casket for the South Kensington Museum –
perhaps its age and runic inscriptions rendered it (for him)
more historical than art historical, more document than art
work; perhaps Robinson's plan for the South Kensington

2. Museum worlds and the bounding of knowledges

Museum collection did not include the acquisition of objects predating the middle ages. Whatever the truth of the matter, the incident adds both complexity and ambiguity and a good degree of arbitrariness even to this small portion of the cultural map produced by the museum world. Indeed, for some years the Franks Casket was, as it were, placeless and excluded from the museum world's map, for the British Museum Trustees declined the purchase. Franks, a man of private means, bought it for himself, and later gave it to the museum in 1867, by which time there was a much fuller sense of the casket's importance and a greater readiness to redraw the map: indeed, the British Museum now had a dedicated department of British and Mediaeval Antiquities and Ethnography.

Boundary work, permeation, fields, discipline

Much of what has been discussed can be classed as boundary work, which can be defined as the development of arguments, practices and strategies to justify particular divisions of knowledge and the strategies used to construct, maintain and push boundaries; or, as Thompson Klein defines it:

> The set of differentiating activities that attribute selected characteristics to particular branches of knowledge on the basis of differing methods, values, stocks of knowledge, and styles of organization (1993: 185).

As should be clear from the historical examples provided above, boundary work can be competitive and territorialising, or can involve the conferral upon others of certain territorial rights: it can be expansive – in seeking to enlarge disciplinary territories – or reductive, in seeking to delimit or down-scale them. Expansive boundary work is about land-grabbing; reductive boundary work operates to distinguish boundaries and may be, as Thompson Klein puts it 'a discursive strategy used by one school' of thought to hegemonise discourse within a discipline (1993: 206). Bal discusses such a representation of disciplinary

unity as 'a powerful ideological weapon because of the pressure it exerts on the reader [or indeed the visitor] to choose one interpretation over another rather than to read through the conflict of interpretations' (Bal 1990: 507; Thompson Klein: 206). (This reconnects with Gieryn's argument that 'cultural cartography also has consequences for the spaces mapped out' (Gieryn 1999: 14)). In the instance of museums, objects, in their intellectually and physically spatialised deployment over different museums, are subjected to the project of forming specific knowledges, and the imagined visitor is disciplined exclusively into a specific disciplinary regime (we will return to explore examples of this in Chapter 4). In this sense both expansive and reductive boundary work represent power plays of different type. Boundary work is, I contend, a key characteristic of disciplinarity generally, but its operation is particularly interesting when disciplines are not entrenched, conventional and naturalised in the way that archaeology and art history are now (which is not at all to say that they are *unified* today); when they are largely undrawn or sketchy maps whose co-ordinates have yet to be fixed and whose first principles of representation have yet to be firmly established. Thompson Klein looks at disciplines with the help of the metaphor of the life cycle, in phases of 'growing, splitting, joining, adapting and dying' (Thomson Klein 1993: 191), and the protean 'growth' stage is suggestive of the play and contest for knowledges in mid-nineteenth-century debates about the artistic and the archaeological.

Much of the work on disciplines and disciplinarity in academia has contended, in alignment with social constructionist understandings, that disciplines themselves are constructs, built of politics and circumstance as well as intellectual endeavour; they are not natural recipients for certain apparently hermetic, self-forming bodies of knowledge (Whitehead 2007: 54). In this context Messer-Davidow, Shumway and Sylvan note:

> If disciplines are such by virtue of a historically contin-
> gent, adventitious coherence of dispersed elements, then
> to study that coherence is necessarily to begin questioning

portrayals of disciplines as seamless, progressive, or naturally 'about' certain topics. In studying disciplinarity, one defamiliarizes disciplines; one distances oneself from them and problematizes their very existence (Messer-Davidow, Shumway and Sylvan 1993: 3).

A further problem emerges in any attempt to define comprehensively any given 'discipline' at any specific moment. Julie Thompson Klein, for example, asks 'What counts as a discipline?' She answers:

> Close scrutiny of epistemological structures reveals that most modern disciplines embrace a wide range of subspecialities with different features. Unidisciplinary competence is a myth, because the degree of specialization and the volume of information that fall within the boundaries of a named academic discipline are larger than any single individual can master ... Consequently meetings of such massive professional organizations as the Modern Language Association, the American Anthropological Association and the American Historical Association are actually congeries of specialities, some isolated from each other, others closely related (1993: 189).

This problem might be seen to concern primarily the gargantuan apparatus of academia in late modernity, with the profusion of universities internationally, with their differently configured departments, schools, colleges and faculties. But it is useful to consider the notion of discipline as 'congeries of specialities' in the context of the early development of specific disciplines, when, far from there being too much content 'for any single individual to master', such content had largely yet to be claimed, and the methods, language and aims of its study were yet to be initialised or distinguished from related leisure practices (such as antiquarianism, in the case of archaeology). It is also worth recalling once more that in the mid-nineteenth century the factories of the disciplines which we now name as

'art history' and 'archaeology' were not universities (whose time had not yet come), but museums.

Disciplinarity, as Messer-Davidow, Shumway and Sylvan put it 'is about the coherence of a set of otherwise disparate elements: objects of study, methods of analysis, scholars, students, journals, and grants, to name a few.' They proceed:

> To borrow from Foucault, we could say that disciplinarity is the means by which diverse parts are brought into particular knowledge relations with each other (1993: 3).

This begs the question: by which actors and through what processes are such 'diverse parts' brought into particular knowledge relations with each other? One might answer this question in relation to academia by considering technological and socio-economic contingencies such as the availability and application of new technologies (Geographic Information Systems, X-ray imaging and carbon dating are good examples, although the two last again point to some overlap between art history and archaeology, if nothing else in relation to technologies of data gathering). In the context of the museum world the actors are its members (again, from curators to civil servants, critics and politicians), possessed of diverse inclinations and diverse forms of social and cultural capital. The processes are the technological, procedural and strategic actions such actors perpetrate over time, through making a speech in parliament about the desirability of creating, uniting or segregating museum collections, through a diatribe in a pamphlet about appropriate forms of display, through the withholding or granting of funds for building work, through acquisitions and appointments, or through the articulation and planning of museum technologies such as collecting, classifying and displaying objects.

Looking at the study of art history and archaeology (if I can be allowed to use these two terms uncritically for a moment, partly to support the project of unpicking their seams), the image is one of dynamic tensions between differentiation and

2. *Museum worlds and the bounding of knowledges*

permeation. This dynamic is not simply enacted between the two disciplines, but also encompasses ideologies, practices and approaches which are carried through from other types of institution, such as the private antiquarian collection (and beyond this, the cabinet of curiosities), the private picture and sculpture collection and the Royal Academy of Art, founded in 1768. The Academy, for example, established: ideologies and boundaries of taste (what, at a given time, it was appropriate and commendable to represent in figurative art); principles of representation in figurative art; and hierarchies of genres and art forms (where painting and sculpture had primacy over engraving, while forms such as ceramics were not admitted, and where history painting had primacy over portraiture, landscape and genre painting). It was also (and is still) an institution which exhibited art, and selected art for exhibition by committee, with all of the politics which this involves (Hoock 2003). These actions permeated the management of the National Gallery in its first decades (and arguably have done ever since), for the values they set about the relative nobility of art forms and genres informed the make-up of the collection. Additionally, as the Academy set parameters about representation it also set parameters about reception and appreciation.

This permeation is not particularly roundabout, for many of the nineteenth-century administrators of the National Gallery were painters and academicians, including the Gallery's first director, Charles Lock Eastlake, who was also President of the Royal Academy. The Royal Academy also shared premises with the National Gallery, and Academy students had special privileges to copy in the Gallery (SCNG 1850: q. 84-5, 120), so that there was a certain binding of ideological discourse and influence between the two institutions, which jointly reproduced constructions of art to audiences. My point is that we cannot view the discursive operation of, and knowledge construction in, the National Gallery as autonomous and independent from coeval or previous institutions of different type. Some writers, of course, have gone further, exploring relations, or at least homologies, between galleries and institutions like department

stores and prisons (Bennett 1995: 30-3; Taylor 1991 and 1999: 117-22) and public parks (Whitehead 2000; Whitehead 2005a: ch. 3). There is an extent then, to which institutional practices with disciplinary outcomes (e.g. in establishing proper objects of study) are permeable or porous.

Simultaneously, actors within the museum world push against norms and perceived atavisms, to distinguish themselves from the practices of others. This is most evident in the development of 'systematic' collections and displays based on articulated and explicit taxonomies. In relation to art, this supplanted (to a negotiated and allowable extent) the dominant discourse of taste. This discourse of taste involved: the canonical representation of a small number of select artists; a general indifference to historiography, chronology or the lost contexts of works of art; and the identification of laudable subject matter and formal treatment as models – models, that is, for transmission of appropriate artistic appreciation among visitors, and of appropriate contemporary practice among living artists. The move to chronological and taxonomic systems can be seen as a form of 'systematic' or 'rigorous' turn in the mid-nineteenth century, linked to the growing professionalisation of curators who sought to distinguish themselves from their 'amateur' or 'dilettante' predecessors. It led to initiatives such as chronological ordering of collections, and the acquisition of objects which fitted well with new ideas of taxonomic work, but not with dominant ideas of taste. Examples of this include attempts to reach back further in time than was conventional, as in Eastlake's campaign to build up a collection of early mediaeval paintings – notably Italian 'primitives', as they were termed.

The introduction of systematic approaches represented both a rupture with, and a challenge to, the authority of existing knowledges and knowledge bearers, so that strategies of all kinds were required to allow for their admittance. Some of these will be explored in Chapter 3, but to give an example, new systematic approaches were, it could be argued, made credible and stabilised through what Foucault terms 'concomi-

tance', whereby statements from different knowledge domains are harnessed to different discourses (Foucault (Archaeology): 57; cf. Lenoir 1993: 74-5). This is one explanation for the use of scientific terminology (particularly from biology and botany) in the taxonomic collection plans drawn up by figures such as Eastlake and Henry Cole (for example, the currency of the term 'specimen' to denote what might otherwise be termed a 'work of art', and of 'scientific arrangement' of paintings in display).

These dynamics between permeation and differentiation and the stabilising invocation of other knowledges give a sense of the heterogeneity of nascent disciplines. Lenoir has discussed this in relation to Foucault's concept of discursive formations:

The notion of clinical medicine as a discursive formation, for example, attempts to capture the connection that emerges in the nineteenth century between statements concerning pathological anatomy, comparative anatomy, tissues, lesions, autopsy, percussion, auscultation, case histories, the hospital, hygiene, statistical method, and so on. The claim is not that statements of this type could not have been, or were not, uttered previously, but rather in this period they came to be *configured* together, while simultaneously other statements concerning, say, miasmas, humors and faculties were excluded from the discourse of physicians (Lenoir 1993: 74).

A similar configuration of statements can be identified in relation to art history as discursive formation in mid-nineteenth century Britain: style, attribution, classification, chronology, school, period, connoisseurship, influence, the museum, specimen, system, high art, excellence, workmanship, edification and so on. Excluded from the discursive formation were obsolete statements pertaining to amateurism and dilettantism, whose sentimental language of appreciation was also purged. Other exclusions are not atavisms, but represent objects of study incompatible with the project of systematising the his-

tory of art: the exclusions concern patronage, commissions, the economics of producing art and what could be termed the sociology of consuming it.

Another consideration in terms of 'permeation' and differentiation: where objects of study (in both senses) may be identical or homologous, as in the instance of the contests between the British Museum and the South Kensington Museum discussed above, the activities of diversely interested figures in the museum world may be 'permeated' by wider political interests and projects. Again, I will explore this with some concrete examples in Chapter 4, but these can be briefly previewed. In the case of the National Gallery, there was a concerted pressure to recognise and promote the moral agency of paintings upon visitors as part of the interrelated programmes of electoral and socio-economic reform. The discourse of the 'moral improvement' of the working class visitor was a critically important one, and it is arguable that the disciplinary action of systematising the history of art in relation to narratives such as the evolution of style, is an example of such permeation. (Some might see this as the harnessing of art history to governmental ends, but this for me is too blunt and simplistic a metaphor for it imputes a large degree of conscious scheming and calculation on the part of politicians, which is not universally evident.) Another example is the permeation of the South Kensington Museum's mission statements of discourses pertaining to *national* economic and industrial wellbeing, so that renaissance sculpture had to be decoded in this sense (it does not particularly matter if the encoding was or is convincing – the objects are still subjected to disciplinary regimes which are permeated by national political interests). Finally, the British Museum's burgeoning collection of Anglo-Saxon objects can be seen to be permeated by wider interests in the construction of a national identity through the representation of a national past (MacGregor 1998: 125). These different permeations contribute to the construction of different disciplinary goals, disciplinary politics and, potentially, disciplinary audiences. They inform or inflect the development of different 'entry points' – 'the concept

or concepts which a theorist uses to enter into, to begin, discourse about some object of analysis ... which will distinctively shape the asking of all questions and which will condition (and be conditioned by) all other concepts within a discourse' (Amariglio, Resnick and Woolf 1993: 184). As such entry points shape questions, they shape answers too.

In this consideration of permeation it is important to recognise its two-way action. Political discourse is not simply imposed upon, or poured into, the museum; to give an example, the rhetoric about improving manufactures and public taste generally which came from the South Kensington Museum was not a simple response to government pressure and dominant political discourse; rather, it was a strategic play *within* discourse – an attempt to configure certain statements together in order to provide opportunities for museum action, for the construction of authority and the pursuance of individual professional interests.

The final perspective with which I want to try to site (and sight) the museum world is that of the *field*, which is the central spatial metaphor in the sociology of Pierre Bourdieu. A field is:

> A network, or configuration, of objective relations between positions. These positions are objectively defined, in their existence and in the determinations they impose upon their occupants, agents or institutions, by their present and potential situation (*situs*) in the structure of the distribution of power (or capital) whose possession commands access to the specific profits that are at stake in the field, as well as by their objective relation to other positions (domination, subordination, homology etc.

Like the museum world, the concept of the field invites us to think relationally (Bourdieu and Wacquant 1992: 96), although Bourdieu, in his comparative discussion of Becker's concept of 'art worlds', points out that the field is 'not reducible to a population, i.e. a sum of individual agents, linked by simple

relations of interaction' (Bourdieu 1993: 35). Fields are essentially competitive systems (conflict and struggle are central to Bourdieu's sociology generally) of relations between individuals (and the institutions they act for). Fields denote, as Swartz clarifies:

> Arenas of production, circulation, and appropriation of goods, services, knowledge or status, and the competitive positions held by actors in their struggle to accumulate and monopolize these different kinds of capital (Swartz 1997: 117).

In its conventional application, *field* is not equatable to single institutions (in either sense, e.g. the British Museum, or abstract institutions like 'medicine'), to discipline, or indeed to the academic use of the term 'field' to denote an area of study. Rather, fields span institutions, which may represent positions within them (Swartz 1997: 120). Fields may overlap, and institutions can be placed within more than one. For example, in Grenfell and Hardy's application of the theory to museums such as the Tate Gallery, they situate the museum within fields such as power (incorporating government funding, and art donors), art, commerce (catering, sponsorship), media (Tate books, TV series etc.), education (guided tours, Tate courses etc.) and technology (Tate website, Tate e-learning programmes etc.) (Grenfell and Hardy 2007: 94). Bourdieu, in his own work, applied the concept to areas such as education, religion, art, literature and others (for an overview see Swartz 1997 and Johnson's introduction in Bourdieu 1993), where all such fields are subject to the field of power, which functions:

> As sort of 'meta-field' that operates as an organizing principle of differentiation and struggle throughout *all* fields ... On the other hand, the field of power can designate for Bourdieu the dominant social class (Swartz 136).

2. Museum worlds and the bounding of knowledges

The concept of field is helpful here because of its emphasis on competition for resources of different types, both economic, such as government funding, and symbolic, such as legitimacy and authority (although we have seen that pure 'competitiveness' does not account for the complexity of actions within the museum world). The legitimacy and authority at stake here is that of the critical interpretations which are made by actors within the field – which might, for example, concern the value and status of objects as either art or archaeology. As Bourdieu puts it:

> Every critical affirmation contains, on the one hand, a recognition of the value of the work which occasions it, which is thus designated as a worthy object of legitimate discourse ... and on the other hand an affirmation of its own legitimacy. All critics declare not only their judgement of the work but also their claim to the right to talk about it and judge it. In short, they take part in a struggle for the monopoly of legitimate discourse about the work of art, and consequently in the production of value of the work of art (Bourdieu 1993: 35-6).

A further motive for thinking about the place of museums within fields is Bourdieu's insistence on their capacity to 'cover social worlds where practices are only weakly institutionalized and practices not well established' (Swartz 1997: 120), and Bourdieu identifies the cultural field (of which museums form a sub-field) as less codified and institutionalised than others like education, which govern admission more strictly (Bourdieu 1991: 15). Nevertheless, there are, for Bourdieu, certain invariant laws – fields are: arenas for struggle for control over resources and for struggle for legitimation; structured spaces of dominant and subordinate positions based on capital; spaces which impose specific types of struggle on actors. And fields are structured to a great extent by internal mechanisms of development, and thus have the capacity to develop a degree of autonomy from other fields, (in particular that of power) in which they might be situated (Swartz: ch. 6).

71

The issue of permeation is also at play within Bourdieu's concept of the field. While Bourdieu allows that fields can develop relative autonomy from the field of power, I would argue that the centrality of culture and of museums in particular in mid-nineteenth-century British political discourse means that the autonomy of museums as a sub-field was not yet well developed. Bourdieu notes that external influences are translated into the specific internal logic of fields (Bourdieu 1984: 6; Swartz 128), which is similar to my understanding of the permeation of museum practices with political imperatives (see above); as stated I will attempt to argue this through more thoroughly in later chapters.

It is the issue of struggle within fields which I want to appropriate from Bourdieu to close this chapter. As stated above, fields involve dominant and subordinate positions and pit actors against each other across this divide. In this context Bourdieu enumerates three field strategies: *conservation, succession* and *subversion* (Swartz: 125). Conservation strategies are pursued by established agents who hold dominant positions and are possessed of the symbolic capital of authority – those who have little to prove or to conquer. For me, this characterises the actions of staff at the National Gallery – most especially its first director, Eastlake, whose longstanding and well recognised cultural capital (he had published numerous scholarly works on art history), together with his professional standing and symbolic and social capital as President of the Royal Academy, afforded him both legitimacy and security. His tenure at the National Gallery was marked by gradual reform – principally in the areas of taxonomy and management – and the protection of a limited domain of material culture (painting) without engaging in any of the plays for territorial control that characterised Henry Cole's directorship of the South Kensington Museum. This latter was a younger institution, and for Bourdieu Cole's actions would be field strategies of succession, where relatively new entrants to the field seek to gain dominant positions. Cole, as is well known, had no particular training in art, and his relative lack of cultural capital

as compared to that of his own staff, like the erudite J.C. Robinson, has been much remarked (e.g. Davies 1998: 173), almost to the point of derision. To overcome this, Cole sought to play out and accumulate the cultural capital which he saw modelled in figures like Robinson and Eastlake; he copied their practices of cultural travel, sight-seeing, documenting his days in journals and acquiring objects (Whitehead 2006). This can be seen as an attempt to cultivate the cultural capital to allow him to be seen as credible player within the field of art, and as such a strategy of succession. At the same time, Cole's position was more complex in some regards, for his insistent siting of the South Kensington Museum within the fields of economics and commerce formed rhetorical strategies to access financial resources and to appeal to different, pragmatist, interest groups in government. Lastly, subversive strategies can be pursued by those who have little to gain or to lose in relation to dominant groups, and can propose radical ruptures to existing knowledge relations. We will encounter this at its clearest in Chapter 4, when the unaffiliated critic and art historian John Ruskin did just this, refiguring in one go the organisational demarcation of the London museums and the entire epistemological basis of their representation(s) of the world.

To summarise these first two chapters: discipline formation in the early public museum is highly complex. It involves actions which are simultaneously epistemological, social and political, as well as others which are circumstantial:

- The identification of content and proper *objects* (in a sense literally) of study;
- The identification and elaboration of appropriate *methods* of study;
- The theoretical potentials and limits of museum actions such as collecting and display for theorising and representing the world or aspects of it;
- Specific goals, capabilities and expertise (Gieryn, Boundary Work 783);
- Relationality and struggle with other knowledges;

- Dynamic plays between permeation and differentiation;
- Professionalisation and specialisation; attempts at distinction from previous and coeval competencies; the establishment of demarcation criteria;
- Construction of professional communities with specialised languages;
- Imagining consumer communities (visitors);
- Political and logistical contingencies and circumstances;
- The making of credibility and authority claims;
- Boundary work and 'cultural cartography' both in individual museums and in 'museum worlds'.

In Part II this book will carry through these somewhat abstract discoveries in order to think about the organisation of knowledges in the historically specific and practical context of museum planning in the 1850s and the consequences this had for disciplinarity and disciplinary differencing. Here, it will be seen, the distinction between 'art' and the 'archaeological' was the central seam or fault line in a debate which determined the development of institutions and ways of thinking and knowing the world and its past.

Part II

Art and Archaeology in 1850s London

3

Notions of archaeology and art
in museum debate

Part II of this book looks at a debate, which took up the entirety of the 1850s, concerning the most appropriate configuration of material culture on the museum world's map of the world. This debate grew from the protean way in which the national museums had developed, from the recognition that their respective contents were sometimes a consequence of circumstance rather than logic and from the general lack of space for the adequate display of existing collections, not to mention expanding ones, which was endemic. This chapter looks at debate about the relative status of art and archaeology in the early 1850s as well as the connotations of these terms for different groups (we will see, for example, how terms such as 'archaeological' could be used pejoratively). It must be acknowledged that in the mid-nineteenth century the term 'archaeology' and 'antiquity' were mobilised in various ways by different communities of practice. Christopher Evans has pointed to this difficulty, commenting that 'archaeology' only came into frequent use in the second half of the century, 'and applied, in particular, to excavated remains, in contrast to the much wider breadth of antiquarian study, which also encompassed manuscripts, standing buildings, jewellery and much else' (Evans 2007: 271). A particular focus of this connotational study will be the identification of boundaries and demarcations, as well as the *use* of objects to establish, transgress or connect boundaries. In this I will look at the Parthenon marbles as boundary objects in the accepted sense of objects which form interfaces for different communities of practice. Later on I will complicate the term 'boundary

object' by proposing new inflections, such as *discrepant, bounded* and *connective* objects, to help understand the ways in which epistemologically problematic bodies of material culture (Egyptian antiquities, for example) were moved around the map to test out categories, representations, practices and histories of the world.

This debate involved large parliamentary enquiries in which attempts were made to establish the domains of the existing museums and to rationalise their contents epistemologically. Many felt that the historic, foundational missions of institutions like the British Museum and the National Gallery had been superseded. For example, the British Museum was founded with the principle of showing its heterogeneous collections to 'studious and curious people' in 1753 (RCBM 1850: 1). As Ian Jenkins notes, its foundation 'was not announced with any grand declaration of museological doctrine' (1992: 16). This, it was felt, no longer encompassed, or gave sufficient detail about, the purposes and perceived values of the museum, which was now seen very much in relation to knowledges: its purpose was variously 'to be a public exhibition of the finest collections in the world in all branches of knowledge' or 'an external representation of that upon which the intelligence of the country has been energising in all the different abstract departments of knowledge' (SCBM 1860: q. 81, 966). There was also equivocation and discord on the issue of whether the British Museum was a natural history museum, an art museum or a history museum (and if it was all three, then why?). All possibilities pointed to a contradictory institution. It was time, in short, to decide exactly what the national museums were for, what they should and should not contain and what intellectual projects should be pursued through them.

This rethink was also intricately related to bureaucracy and professionalisation, as the management structures of the museums came under increasing scrutiny and a slow process of reform was enacted. In this, largely aristocratic trusts learned to accommodate professional posts requiring professional competencies and expertise, which bore closely on questions about

museums and knowledges. (This was not a ceding of power but a reformulation of relationships which, it might be argued, also had something to do with the gradual re-imagining of the citizenry which accompanied electoral reform.) In the comments and opinions of curators, critics and politicians can be found myriad suggestions for the reconfiguration of the museums themselves, involving reorganisations of knowledge and the establishment of specific demarcation criteria to bound and discipline bodies of material. In the early 1850s this was highly exploratory in nature, and both here and in the next chapter, which deals with major proposals for the reorganisation of knowledges put forward by actors within the museum world of the 1850s, we will see tensions between reductive and expansive boundary work, conservative tendencies and the allure of radical rethinks.

This magnitude of the debate in the 1850s is hard to imagine today, when distinctions between art and archaeology are hardly pressing concerns for governments. And yet in the 1850s many thousands of pages of parliamentary papers were produced on the matter, which received close attention from many of the most important statesmen of the day: figures such as Sir Robert Peel and Benjamin Disraeli populated Select Committees and instigated involved debates in Parliament about such topics. The profound engagement of the political elite with the management of the London museums is very clear from a reading of lists of their Trustees. In 1850, the official trustees of the British Museum, for example, included most of the principal officers of government, from the Lord Chancellor, the First Lords of the Treasury and Admiralty, the Chancellor of the Exchequer, the Colonial, Foreign and Home Secretaries, to the Lord Chief Justices and so on, as well as religious leaders such as the Archbishop of Canterbury and leading cultural figures such as the presidents of the Royal Society, the College of Physicians, the Society of Antiquaries and the Royal Academy of Arts; alongside these, family trustees (hereditary positions occupied by descendants of important donors) and elected trustees included both major

politicians and prominent members of the aristocracy (RCBM 1850: 3). While it was admitted in the 1850s that such Trusts were often unwieldy and inefficient management structures (SCBM 1860: q. 1621; Whitehead 2005a: 130-2), their membership is nevertheless a mark of the significance of museum representations within wider political projects. At a time of gradual upheaval in society (in particular with electoral reform) and the economy, museums furnished epistemological frames whose key role in disciplining the knowledges of the citizenry was more or less tacitly recognised as useful for civil and economic 'progress'.

Knowledge legacies

At the beginning of the 1850s the London museum world was a messy one. The largest institutions were the British Museum, founded almost a century earlier in 1753, and the National Gallery, founded in 1824. Smaller institutions included the Dulwich Picture Gallery, the Museum of Practical Geology established in relation to the Geological Survey in 1835 and numerous other institutions which were private concerns, such as Nathan Dunn's Chinese Collection in Knightsbridge, Giovanni Belzoni's Egyptian Hall in Piccadilly and the Phrenological Museum on Strand, some of which were spectacular in emphasis. The South Kensington Museum had not come into being at this point; only after the Great Exhibition of 1851 were funds allocated to the consolidation of some form of museum of 'ornamental' art or 'manufacture' (the terms were used rather loosely and interchangeably), and only in 1853 was the Museum of Manufactures established in the Crown property of Marlborough House on Pall Mall. This was a precursor to the South Kensington Museum which opened in 1857. It was this messiness which many sought to tidy up through the reorganisation of the various collections and their rehoming in one locality in Kensington park land. This involved a partnership between the government and the Commissioners of the Great Exhibition of 1851, and figures like Prince Albert

schemed to build a complex of museums and other institutions. Plans relating to this complex remained vague, but oft-cited inclusions were collections pertaining to science, art, trade and commerce, patents as well as learned societies and schools (Whitehead 2005a: 156). This possibility formed one of the bases for extended debate.

In the early 1850s the largest and most heterogeneous collections were those at the British Museum. There were seven departments: manuscripts, printed books, antiquities, prints and drawings, and, forming the 'division' of natural history, mineralogy, zoology and botany (RCBM 1850: 2). This configuration of material was due in part to the founding collection of Sir Hans Sloane, which, like many Cabinets of Curiosity, was wide-ranging, artfully incorporating both *artificialia* and *naturalia* (Moser 2006: 12); although, aside from the library, natural history predominated. Alongside Sloane's collections were the Cotton and the Harleian collections of manuscripts, the former of which had belonged to the nation since 1700, but had remained homeless, while the latter was acquired. The Museum also had collections of paintings. There were portraits which were eventually moved to the National Portrait Gallery which opened in 1856, although in 1860 there were still portraits in the ornithological gallery (SCBM 1860: q. 329) – a measure of the confusion of material in displays. The picture collection of Sir George Beaumont had been acquired in 1823 and subsequent to the foundation of the National Gallery the following year was lodged there, although British Museum trustees made a show of viewing the paintings emphatically as part of the *Museum's* collection and not the Gallery's, inspecting them annually in order to assert this claim, to the annoyance of Gallery staff (SC 1853: q. 5303; Whitehead 2005: 69, 83-4 (note 4)).

Man-made antiquities came into the museum over the following decades and the collections grew as opportunities arose: the collection of antique vases and other antiquities purchased from Sir William Hamilton in 1772, the Egyptian collections (seized from the French during the Napoleonic conflict) in

1802, the Townley Collections of classical sculpture in 1805 and, of course, the controversial acquisition of the Parthenon marbles through the agency of Lord Elgin in 1816. Later, in the 1840s, Austen Henry Layard excavated Kuyunjik, Nimrud and Babylon, providing the museum with the foundations of its Assyrian collections. Within the Department of Antiquities there was also an ethnographic collection, defined as 'a collection of arms, implements, dresses and idols of different nations' (SCBM 1860: q. 269). The symbolic and practical values which were ascribed to such foreign antiquities were mutable. To illustrate this it is worth looking at the reception and accommodation in the museum of a couple of high profile examples.

Mutating values: the Parthenon marbles and Egyptian antiquities

The Parthenon marbles were not primarily valued for their antiquity or socio-historical properties *per se* when they were acquired in 1816, but rather for their artistic ones. But this evaluation was not a simple or obvious process. They were in a sense *culturally produced* as art through the debates surrounding their acquisition, and this involved appeals to contemporary artistic practice and discourse and to national identity which were situated in a context of post-war demobilisation and governance. The Select Committee 'on the Earl of Elgin's Collection of Sculptured Marbles', which was convened in 1816, met to discuss four things: the authority by which the marbles were acquired; *how* that authority was acquired; the 'Merit of the Marbles as works of Sculpture, and the importance of making them Public Property, for the purpose of promoting the study of the Fine Arts in Great Britain'; and their financial value (SCEEC 1816: 3; on the circumstances of their removal from Athens see St Clair 1967, Hitchens 1997, Skeates 2000: 30-5 and Wilson 2002: 71-5). A number of contemporary sculptors – among them Joseph Nollekins, John Flaxman, Francis Chantrey and Richard Westmacott – were convoked and quizzed about the value of the marbles as works of art, as were

the painters Thomas Lawrence and Benjamin West (together making up 'several of the most eminent Artists in this kingdom') along with the classical scholar and aesthetician Richard Payne Knight. There was a consensus that the marbles were 'in the very first class of ancient art', as the report of the Committee summarised:

> Some [of those convoked] placing them a little above, and others but very little below the Apollo Belvidere, the Laocoon, and the Torso of the Belvidere. They speak of them with admiration and enthusiasm; and notwithstanding the manifold injuries of time and weather, and those mutilations which they have sustained from the fortuitous, or designed injuries of neglect, or mischief, they consider them as the finest models, and the most exquisite monuments of antiquity (SCEEC 1816: 6).

In this passage the marbles are effectively consecrated by their comparison with already consecrated sculptures: their firm identification as art comes about through their intersubjective placement within a 'class' of quality invoking a systematically organised canon. With this classification the marbles must be stripped of their history to stand as universal 'models', for their artistic qualities are perceived 'notwithstanding' their form which has been compromised by history (cf. Siegel 2000: 61-3). The marbles are also stripped of their story in the other sense, for no mention is made of the representational and documentary value of the Parthenon frieze for an understanding of culture and religion in classical Athens – an issue to which we will return shortly in examining Charles Newton's very different evaluation of the marbles in the mid-century. The marbles are placed within the territory of art through the deployment of concomitant discourses. Firstly, the marbles are *attributed* to Pheidias, forming an appeal to the primary importance of authorship in discourses of art. Secondly, an appeal is made to the educational qualities of the marbles as 'works':

It is natural to conclude that they are recommended by the same authorities as highly fit, and admirably adapted to form a school for study, to improve our national taste for Fine Arts, and to diffuse a more perfect knowledge of them throughout this kingdom (SCEEC 1816: 6).

Here, the 'school for study' is both abstract and literal, for the practice of providing contemporary artists with classical works for imitation was then invoked, presaging the marbles' potential to trigger a new renaissance in Britain, with, subtextually, all of the civic, economic and symbolic benefits associated with this:

Much indeed may be reasonably hoped and expected, from the general observation, and admiration of such distinguished examples. The end of the fifteenth and beginning of the sixteenth centuries enlightened by the discovery of several of the noblest remains of antiquity, produced in Italy an abundant harvest of the most eminent men, who made gigantic advances in the path of Art, as Painters, Sculptors, and Architects (ibid.: 7).

The housing and classification of the marbles was in this way intimately connected to the representation of the nation, at a moment of some significance after Waterloo. As Jenkins points out, the subtext of much of the rhetoric about the acquisition was the legitimacy of Britain's claim to manage the foreign past, as contrasted with the illegitimacy of France's claim; Napoleon's spoliation of antiquities in Europe and Egypt was in fact seen as having been rendered possible only through bloodshed (Jenkins 1992: 19), and in this sense the cultural project of appropriating and managing the marbles can easily be sited within the field of power (see Chapter 2). To put it another way, the museological action of acquiring the marbles permeates, and is permeated by, political strategies of representation in which high art and (British) free government are co-constitutive:

3. Notions of archaeology and art in museum debate

If it be true, as we learn from history and experience, that free governments afford a soil most suitable to the production of native talent, to the maturing of the powers of the human mind, and to the growth of every species of excellence ... no country can be better adapted than our own to afford an honourable asylum to these monuments of the school of *Phidias*, and of the administration of *Pericles*; where, secure from further injury and degradation, they may receive that admiration and homage to which they are entitled, and serve in return as models and examples for those who, by knowing how to revere and appreciate them, may learn first to imitate, and ultimately to rival them (SCEEC 1816: 15).

Such rhetoric also connects to discourses of neoclassicism in the arts, which had arguably dominated the study of classical antiquity prior to the marbles' arrival in Britain. In this context 'art' formed in some sense a much naturalised classification for the marbles. This naturalisation was played out in various ways: through interrelations such as the privileged admittance of Royal Academy of Arts students to the British Museum; through the convention that the Professor of Sculpture at the Academy should advise British Museum staff on the display of classical sculpture; and through the President of the Academy's involvement as an ex-officio trustee (Jenkins 1992: 30-8). It also took place in symbolic representation. Consider Archibald Archer's painting of the Temporary Elgin Room (Fig. 3), representing a kind of *conversazione* (in effect a kind of *School of Athens*, and the influence of Raphael may well be at work) centred on and channelled by the marbles. Portrayed within the room are many of the officers of the British Museum, with some prominent others, such as the painter Benjamin West (president of the Royal Academy) in the left foreground in conversation with the British Museum's Principal Librarian, Joseph Planta. As Jenkins notes, this central pairing 'appears to celebrate the close association of the two institutions most responsible for the state of the arts in Eng-

land at this time: the Royal Academy as chief practitioner, and the British Museum as custodian of the highest examples of antique art' (1992: 76). We see Sir Charles Long (afterwards Lord Farnborough) the Paymaster General behind West, and the painter Benjamin Robert Haydon, on his own in the left background, drawing inspiration from the marbles (Jenkins 1992: 37). Archer, the artist, pictures himself portraying the scene, and unidentified figures (visitors?) – some of them female – skirt the margins of the room. These are the imagined constituencies of the marbles: politicians, custodians, artists as users, visitors as beneficiaries. The marbles are set forth, in this context, as a *boundary object*; such are:

> those objects that both inhabit several communities of practice and satisfy the informational requirements of each of them ... Such objects have different meanings in different social worlds but their structure is common enough to more than one world to make them recognizable, a means of translation. The creation and management of boundary objects is a key process in developing and maintaining coherence across intersecting communities (Bowker and Star 1999: 297).

This emblematic *conversazione* was, however, somewhat aspirational, for as Jenkins argues, the influence of the marbles on artistic practice was not as considerable as had been hoped, as the primacy of neoclassical discourse waned somewhat over the rest of the century. Later on, the use of marbles as a boundary object became strained in some instances: the Royal Academy's Professor of Sculpture Richard Westmacott clashed with museum staff over the arrangement of the marbles and quarrelled with the assertion that classical sculpture had been polychrome (this did not fit with prevailing neoclassical discourse) (Jenkins 1992: 51-2). Similarly, the marbles proved to be difficult exemplars for art students, who were used to drawing inspiration from the canon of Graeco-Roman sculpture, so that the marbles' influence on contemporary art was limited and the

high aspirations of the 1816 committee for a new renaissance failed (Jenkins 1992: 29). While the marbles were classified as art, they were also pulled in other directions. Jenkins argues that the unusual decision not to restore them meant that they retained 'an archaeological purity of form that appealed not so much to the senses as to the intellect' (ibid.: 29; cf. Coltman 2006: 180). The marbles' evident subjection to historical events which caused them to change in form was not hidden from view so that they did not readily take on the transhistorical, frozen-in-time aspect of works of art (see Chapter 1). There were recurrent and vexed concerns as to whether the display of the marbles should be arranged decoratively or whether it should reference their original context in the Parthenon, in which case the frieze would not have been seen at eye level, the metopes arranged with casts of triglyphs and the pediment sculptures might have been framed by reconstructions of the pediment architecture

(Jenkins 1992: 85, 95); this concerns the discursive operation of architecture and display discussed in Chapter 1, and shows how different historiographical statements could be made about the marbles through these media.

By 1853 the blend of values ascribed to the marbles was complex, subsuming both their perceived artistic merit and newer concerns about their contextual and iconographical study which went beyond the formal schemes (e.g. the analysis of 'style') associated with art appreciation. Charles Newton's proposals for the study of the marbles and other antiquities was more nuanced than previous understandings of them as 'art', and, as I will argue later, more sophisticated than contemporary approaches to the study of post-classical art such as paintings. After establishing the artistic primacy of the marbles as a *ne plus ultra* of excellence, a 'model by which the taste, not of the English people only, but of all future civilised nations, may be formed and elevated', Newton wrote:

But we cannot appreciate the art of Phidias merely by contemplating the scattered fragments of his great design as they are presented to us in the Elgin Room; we must study the larger figures and torsos as forming part of two great compositions set in the triangular frames of the pediments; we must regard the metopes not merely as individual groups, but as a series of ornaments intended to relieve the monotonous parallelism of horizontal lines in the exterior view of the Parthenon. In criticizing the frieze, we must remember that it was intended to be seen from below, in the subdued light of a colonnade, not to be placed on a level with the eye, as it is at present.

Having regarded the Elgin marbles in their relation to the architecture of the Parthenon, we must next consider them as expressive of the thought of the artist. The design of Phidias was, in fact, a sculptured poem, in which he celebrated the glory of Pallas Athena as the tutelary goddess of the Athenian people. The frieze, the metopes, the pedimental compositions, the chryselephantine statue of

the goddess within the temple, all had reference to this main theme. This great design has, unfortunately, not been handed down to us in the perfect state in which Phidias conceived and executed it; but much more may be done by the study of collateral evidence, for the illustration and reunion of the fragments which we possess (Newton in SCNG 1853: 774).

The sophistication in this intellectual project is the diversification of objects of study so that the marbles themselves were no longer unique foci. A lot could be learned through the study of the marbles about objects external to the marbles themselves, and the reverse also obtained. For Newton, this rich contextual study formed the particular province of archaeology:

This collateral evidence it is the business of archaeology to collect and prepare for the general public (ibid.).

Notably, the identification of the marbles as art is not contested by Newton. Rather, the key issue here is the movement of the marbles *within* the concept of art, for the project and methodologies of engaging with the marbles undergo a shift as they are shown to support knowledges other than that of aesthetic appreciation.

The classification of Egyptian antiquities as art was less agreed upon. There were 160 Egyptian antiquities in the British Museum upon its foundation in 1753, and more were added through donations before its opening three years later (Moser 34-5). In her book on the collecting, display and reception of Egyptian antiquities at the British Museum, Stephanie Moser has carefully charted their critical fortunes. She shows that the value initially ascribed to Egyptian antiquities was as curiosities and sometimes monstrosities, even though the serious antiquarian study of such objects was underway by figures like Bernard de Montfauçon and the Comte de Caylus (Moser 2006: 42). For Hans Sloane, Egyptian antiquities were 'unusual and rare and had the same currency as crocodiles, armadillos,

puffer fish, narwhals' tusks and other such desirable "collect-ibles'", and as such were presented in the context of the public museum as objects 'deemed appropriate for superficial consumption rather than deeper intellectual contemplation' (Moser 2006: 41). This perception did not shift quickly or thoroughly, although the arrival in 1802 of the French collection which had been seized in the aftermath of the Battle of the Nile saw the addition of a further layer of meaning, in which the antiquities took on the symbolic value of trophies connoting the victory of Britain and the vanquishing (at least in Egypt) of the French (Moser 2006: 85). In 1764 Johann Joachim Winckelmann published his *Geschichte der Kunst des Alterthums* or *History of Ancient Art*, in which he plotted a teleological narrative of art whose qualitative apex was ancient Greece; Egyptian 'art' was cast as the primitive precedent in this story, contrasting unfavourably with classical Greek art in part because of its degrading Africanness – the resemblance of figures to the physical form of the 'African' (Pope 2007: 167). This narrative involved a claim that Egyptian antiquities *should* be considered as art, but that they were inferior examples as such. At the British Museum this subordinate status was played out in display in which Greek and Graeco-Roman sculpture was privileged at the expense of Egyptian sculptures through their relative positioning, visibility and lighting (Moser 2006). As late as 1860, we find the Keeper of the Department of Antiquities, Edward Hawkins, being quizzed about the inadequacy of lighting in one of the display spaces:

> In your gallery, have you not a number of objects so simple, that they do not want much light for the purpose of examining them? – It is for that reason that we put the Egyptian sculptures into this gallery (SCBM 1860: q. 1795).

So, Winckelmann's scheme notwithstanding, the status of Egyptian sculpture as art was still contested, as illustrated in the natural historian Joseph Banks' dealings with Henry Salt

over the acquisition of the latter's collection, which included the monumental bust of Ramesses II (Fig. 4):

> We are here much satisfied with the Memnon [i.e. Ra-messes II], and consider it as a *chef-d'oeuvre* of Egyptian sculpture; yet we have not placed that sculpture among the works of *Fine Art*. It stands in the Egyptian Rooms. Whether any statue has been found in Egypt can be brought into competition with the grand [Graeco-Roman and Roman] works of the Townley Gallery remains to be proved (in Moser 2006: 101).

Although the terminology of art (*'chef-d'oeuvre'* or *masterpiece*)

91

is employed strikingly, the relegation of the bust suggested, as Moser argues, that it was definable as art 'only when in the company of the other Egyptian antiquities' (ibid.), and this represents a significant theoretical and cartographical act. However, it was this same bust which led to a shift in perceptions, for it was received well by critics and scholars, who employed the language of aesthetic appreciation to describe it, working against prevailing conceptions of Egyptian antiquities as colossal monstrosities or curiosities (Moser 2006: 115). In part this was a consequence of the bust's mimetic quality as the imitation of nature was a paramount value in discourses of art; in part it also has to do with the perceived physical beauty of the face, which worked against Winckelmann's disparaging comments about African physiognomy.

By the 1850s Egyptian antiquities still occupied uncertain terrain. This was thrown into sharp relief in the parliamentary debates of 1853 about the possibility of providing a new building for the National Gallery, which prompted discussions about what should go where. In this instance, the artist William Dyce was convoked and asked whether he agreed that the 'great distinction' between the British Museum and the planned new National Gallery was that the former should contain the 'archaeological' and the latter 'the artistic'. Dyce did agree with this proposition, but made a point about the difficulty of demarcation:

> no doubt in general it would be comparatively easy to say that such and such an object belonged to the department of archaeology, and that such another object belonged to the department of art; but there would be cases sometimes between these two, in which it might be difficult to say to which institution it ought to belong (SCNG 1853: q. 7663).

Notably, 'Egyptian art' was then invoked in this context as a body of material likely to be the cause of such confusion. Dyce was asked whether he would exclude from the art museum 'all specimens of Egyptian art' but emphasised that he would select

only 'those that tended to illustrate the history of art' (SCNG 1853: q. 7664; Whitehead 2005a: 74). He did not elaborate on what criteria objects had to fulfil in order to 'illustrate the history of art' or indeed, conversely, to be 'archaeological', but it is clear that the principle of segregation presupposed real categories with inherent differences associated with different knowledges.

The event at which Dyce was interrogated was the Select Committee 'Appointed to Inquire into the Management of the National Gallery; also to Consider in what Mode the Collective Monuments of Antiquity and Fine Art Possessed by the Nation may be most Securely Preserved, Judiciously Augmented, and Advantageously Exhibited to the Public'. This, as its title suggests, was the most important forum to date on the relationships between museums, objects and knowledge. We shall now look at this in some depth.

Tabula rasa

In the early 1850s the first major public enquiries were brought about because of the combined concerns about constraints on space, expanding collections and the boundaries between them, museum management, visiting and visitors and the question of where museums should be sited within the metropolis. Many of these concerns were profoundly interrelated, but we shall concentrate here on the issue of demarcations between collections. There were stirrings on this topic as early as the Select Committee on the National Gallery of 1850. Some of this came about through well established concerns. The artist William Mulready, for example, advocated the development of a sculpture collection at the National Gallery for the purpose of providing exemplars for artists, and the Gallery's value as training ground was evidently uppermost in his mind (SCNG 1850: q. 918-22). The National Gallery's ex-keeper and future Director Charles Lock Eastlake stated that 'it might be a question whether all works of art ought not to be under the same roof' but stopped short of advocating it, preferring, along with Sir Robert Peel 'to confine ourselves to obtaining a very good Na-

tional Gallery for the admission of pictures' (ibid.: q. 5154-8). Later on, his position became more ambiguous, as he pointed out the desirability of being able to refer 'from a picture to a statue' and pointed out that 'in most foreign galleries ... sculptures and paintings are under the same roof' (q. 522-3). He was less equivocal, however, about the need to house collections of prints and drawings alongside the Gallery's paintings: prints of paintings in foreign museums provided material for comparative study, while drawings gave insights into the working practices of artists. The impediment to this scheme was institutional, for the British Museum's collection of prints and drawings had been 'presented by persons specifically to the Trustees' (ibid.: q. 521) and thus were bound to remain there.

By 1853 this area of debate had become much more pressing and there was an openness to complete rethinks about the institutional boundaries of collections, with the frequent invocation of a kind of *tabula rasa* – the construction of a new museum building or museum complex, possibly in one of London's parks, for the juxtaposition of the nation's '*Collective* Monuments of Antiquity and Fine Art' (SCNG 1853; emphasis added); in this prospect, the institutional identities of the National Gallery and the British Museum would simply be dissolved and their local politics eradicated. The 1853 Select Committee was a massive endeavour with over 40 witnesses convoked and a final publication of over 1,000 small-print pages. Additionally to the witnesses, a questionnaire was sent to the principal 'Galleries and Museums of Fine Art in different Countries', with answers returned from Belgium, Berlin, Florence, France, Munich, Naples, Rome and St Petersburg. The first of these questions was: 'are the national collections of antiquity and fine art in [x] united in a single building, or in buildings contiguous to each other?'; this was closely followed by: 'what are the precise definition and limits of the classes of objects exhibited or preserved under the head of "antiquity and Fine Art"?' (SCNG 1853: 752). This represented the Committee's exploration of knowledge relations and demarcations which had been established elsewhere. The results, as one

94

might expect, varied greatly. The primary motif of the investigation into witnesses' attitudes to these issues was the search for demarcation criteria, and as we will see in the next chapter, this was to intensify in the latter half of the 1850s. We have seen how delicate and opaque this process could be in relation to Dyce's views on Egyptian sculpture. During the same interrogation, Dyce was asked whether he would 'draw any distinction between objects of antiquity, in the stricter sense, and objects of fine art'; his response was ambiguous and circular, although a criterion concerning age is somewhat evident:

> I think that in the formation of a National Gallery, art ought to be had regard to; ancient works of art, because they are ancient, necessarily belong to some department of archaeology; one cannot avoid the archaeological view ... but still I think the principle of an artistic arrangement of the collection might be kept in view (SCNG 1853: q. 7475).

He proceeded to explain his vision for an 'art' museum containing three departments of painting, sculpture and architecture, collections for which would be assembled from others in existence:

> I should imagine that such objects as were applicable to this great art collection ... would be transferred from the British Museum or other locality in which they happen to be (ibid.: q. 7567).

The questioner then pressed Dyce to establish whether the demarcation criterion at work was in fact aesthetic, noting that he appeared to propose 'to pick out all the prettiest things from the British Museum, and bring them to this new building' and tested Dyce with reference to a practical example:

> Supposing there were a valuable manuscript in the British Museum, would there not be any difficulty in selecting it from others, because it happened to have a pretty illumination on it?

Dyce noted in response that there were manuscripts in the British Museum 'which are not valuable as literary productions, but which are valuable on account of their decoration' (SC 1853: q. 7660), and proposed that such decisions could be made by a specially appointed commission. Manuscripts were one of a number of objects which were used instrumentally in debate to identify boundaries in that they were *contended*, as the upholders of different museological and knowledge regimes actively competed for the right to appropriate and steward them. In this sense they formed 'boundary objects' of a different kind, not in that they provided an objective interface for different communities of practice as discussed earlier in the context of the Parthenon marbles, but because of their employment within attempts to differentiate knowledges while actors within the museum world sought to pull them over boundaries into their own territories.

The staff of the British Museum who were questioned held quite different views from Dyce and, in some instances, from each other. The Keeper of Antiquities, Edward Hawkins, was sure that the National Gallery's paintings should be united with the British Museum's collections, noting that 'all collections of antiquities comprise objects of very high art' (ibid.: q. 7746) but he was not prepared to segregate anything. When asked whether he had not anything in the collections 'under the head of archaeology which does not connect itself so closely with the department of art, that it would be more or less interfering with the objects of such a combination, to separate it from the other branches under your care', Hawkins emphasised that it would 'destroy the whole object of the department to separate any part of it' (ibid.: q. 7761), and noted that in his scheme, paintings would simply comprise an additional branch in a department of antiquities (ibid.: q. 7765, 7778). Hawkins' assistant, Edmund Oldfield, who worked on numismatics and classical sculpture, took a quite different view, although he too objected to a distinction between 'high art' and 'barbaric art or archaeology', as it was put by one member of the committee (ibid.: q. 8284). When asked about the amalgamation of collections Oldfield replied:

3. Notions of archaeology and art in museum debate

In my opinion it is incorrect to view the British Museum as a collection of works of art; it is, in its primary character, a collection of antiquities of the highest value as illustrative of history (ibid.: q. 8283).

If the paintings had to be united with the antiquities, Oldfield insisted that they should not be intermingled.

A third employee (of sorts), the sculptor Richard Westmacott, brought further perspectives. As stated, the fact that the duty of 'arranging' the classical sculpture fell to him as Professor of Sculpture at the Royal Academy of Arts was a circumstance relating to their historical siting within a discursive field of 'art' which we saw in operation in the debates about the Parthenon marbles in the early nineteenth century. His approval of the project to amalgamate collections was similarly rooted in discourses of art, for it was predicated on notions of what would be most useful for artists in training, who made up the majority of his imagined visitors (ibid.: q. 9032-50), and for them a combination of exemplars of sculpture and painting was seen as desirable. However, Westmacott also appeared to appreciate the view that 'archaeological' objects should not be segregated on the basis of aesthetic value, although as will be seen there are contradictions in his evidence. The committee attempted to draw Westmacott on a demarcation criterion repeatedly, using first Egyptian and then Assyrian and Etruscan material culture, all of which he admitted into his scheme (ibid.: q. 9008-9). For the committee these formed *discrepant* objects, in that they were used instrumentally to explore discrepancies in the knowledges and knowledge relations invoked by witnesses. They were discrepant because – as shown in the earlier discussion of the critical reception of Egyptian sculpture – they did not fit perfectly within a notional consensus category of art and were difficult to consecrate, because of the exclusive character of contemporary discursive formations of art (see Chapter 2). As another example, the art historian James Dennistoun argued for the amalgamation of collections, but with the exception of the 'antiquities of Mexico', which were, for him,

insufficiently artistic (ibid.: q. 5897). As an authority on art Westmacott could also make a (cartographical) claim about some objects – when asked whether he would include Etruscan vases within his notional museum he replied: 'certainly, because they are works of art, and very fine works too' (ibid.: q. 9022). In this sense he attempts, through a play of authority, to move Etruscan vases from the status of *discrepant* object, as the Committee presented them, to firmly *bounded* object, squarely within the province of art. This is also a process of consecration. Westmacott was, however, prompted to think about demarcation when the question emerged of whether medals should be included:

> I cannot exactly say that; there are, no doubt, very historical and beautiful works among the medals, but I do not know that they are such works of art as should be combined with the others. I should say that everything, even the Egyptian antiquities, the mummies and all the monuments of Egypt, should be brought together, with the marbles ... I certainly think that sculpture and pictures should go together (ibid.: q. 9018).

Westmacott's attitudes seem to have been forming as he spoke, for in the first instance he proposes to segregate art from non-art and in the second, in relation to other examples of material culture, he proposes to unite them. Ultimately, he admitted that his demarcation was untenable – the medals 'must all go or none' and 'everything belonging to archaeology should be kept together' (ibid.: q. 9021, 9019), involving an indiscriminate collection of everything.

In 1853 the proposal to amalgamate collections was generally popular, although there were differences of opinion as to what that amalgamation should comprehend and what it should not. A smaller number of people opposed the idea generally. These were primarily artists such as George Foggo, Frederick Hurlstone and Morris Moore. They objected to amalgamation on two principal grounds. Firstly, they argued that

visitors were simply confused by large heterogeneous collections and unable to enjoy objects 'with moderation' (ibid.: q. 7412); additionally, as Foggo put it, 'the desire we have for quantity and multiplicity ... creates a national vanity rather than a taste' (ibid.: q. 7411), all of which cast heterogeneous collections in a slightly dubious moral light. Secondly, their views represented those of many artists who desired to see a National Gallery in which paintings alone were displayed, and only paintings which were consecrated and firmly canonised (notably, this would mean excluding mediaeval paintings). Moreover, historiographical systems of display in which paintings were ordered sequentially by date were similarly disparaged as 'archaeological'. As Hursltone argued:

I look on the object of a National Gallery as perfectly distinct from a mere archaeological museum of art ... the purpose of a National Gallery is to place before the public, for the study of artists, the finest works of human talent; but if you come to take it in the lower view of a mere historical memorial of art, you will have to combine a variety of inferior specimens, and the system of the whole thing will be perfectly different (ibid.: q. 7215).

This formed a particularly reductive form of boundary work in which material culture was categorised in relation to aesthetic quality, and the knowledge of aesthetic appreciation was valued much more highly than ('lower') historical knowledges: here quality is exclusive of history and chronologies are eradicated in favour of transcendent value. At the same time, a particular ocular logic was involved in the segregation of objects such as paintings and sculpture. As Foggo put it, 'no persons connected with the profession [of art] ever like the appearance of sculpture with paintings':

You have to prepare your mind to get over the absence of colour, and the deficiency of imagination, the human eye, when seen with all its liquidity, motion and transparency,

is very different from what we see in the Venus de Medicis (ibid.: q. 7413-14).

One of the most interesting proposals for segregation came from the celebrated Bavarian architect Leo von Klenze, who had designed some of the most important museum buildings in existence – the Glyptothek and Alte Pinakothek in Munich and the new Hermitage in St Petersburg; consequently Klenze's status and authority within the cultural field was high and his opinion carried much weight. His rationale for segregation was architectural, because he believed that paintings and sculptures had different lighting requirements. However, he was keen to integrate bodies of material culture epistemologically in other ways. He proposed, firstly, a kind of complex of museum buildings, each with substantive collections, and added that individual museum buildings could be linked by passages which would form physical and literal communications between them. As an example, he suggested that 'the passage through which you passed from the sculpture to the paintings should be adorned by a collection of vases, which form the intermediate step between painting and sculpture' (ibid.: q. 9362). In this view, vases are boundary objects in a new *connective* sense because they literally inhabit boundaries, connecting domains.

In addition to the evidence given by witnesses convoked by the Committee, two significant museological proposals were put forth by officers of the National Gallery and the British Museum respectively. These were important and influential documents and their respective authors were operating strategically in publishing them in association with the Committee report (both documents were appended). Both of them represent attempts to protect and circumscribe territory in the uneasy debate about museums, objects and knowledges. These proposals, along with others from the later 1850s, are the focus of the next chapter.

4

New boundaries

This chapter looks at a number of major proposals for the organisation of London's national museums which to this day have important consequences for the management of knowledge. The question which they address was succinctly encapsulated by the Member of Parliament William Henry Gregory, in one of the questions he put to a witness during the 1860s Select Committee of the British Museum which he chaired. Speaking of the issue of drawing demarcations and amalgamating collections, he endeavoured 'to get to the principle that lies at the bottom of this':

> Is the principle this: that everything that is worth knowing ought to be in close juxtaposition with everything else that is worth knowing? (SCBM 1860: 975)

The discussion that follows charts some of the responses to this question.

Eastlake's art history

In 1853 Charles Lock Eastlake was President of the Royal Academy and a trustee of the National Gallery; he was heavily involved in debates about the management of the Gallery and was ultimately appointed to the post of Director in 1855. He had clear strategic interests in seeking to influence the parameters of the institution and to define its boundaries. To pursue this, together with the Keeper Ralph Nicholson Wornum, he co-authored a *Plan for a Collection of Paintings, Illus-*

trative of the History of the Art. This provided a map for the development of the collection, and was published as an appendix to the Select Committee of 1853. The *Plan* was presented to the Select Committee as though Prince Albert had had the idea for it and had then commissioned Eastlake and Wornum to articulate it. While this may be, it is more likely that the idea originated with Eastlake, who probably orchestrated Prince Albert's involvement to secure an apparently disinterested means of delivering the *Plan* to the Committee and to give it the imprimatur of the Prince's endorsement. In a Bourdieuan sense the episode can be seen as an exchange of cultural for political capital between the two men, and Eastlake's position within the field of culture (itself within the field of power), allowed him to co-opt royalty to achieve his purpose. In the letter to the Select Committee which introduced the *Plan* neither the dissent surrounding the issue of the purpose, collection and displays of the National Gallery, nor the question of its relations to other institutions, were mentioned, and the *Plan* was given the strategic gloss of an object of consensus (notice also the notion of 'scientific' study):

From what he has read of the debates in Parliament on the subject, as well as from a perusal of many pamphlets that have been written upon it, His Royal Highness [i.e. Prince Albert] is induced to believe that there exists at present no difference of opinion as to the objects which should be kept in view in the conduct of a national gallery. Indeed, public opinion seems to be agreed that, as far at least as relates to painting, it should be as complete a school of art as it is possible to create; and with this view, that the endeavour should not be merely to form a collection of pictures by good masters, such as a private gentleman might wish to possess, but to afford the best means of instruction and education in the art to those who wish to study it scientifically in its history and progress ... His Royal Highness has thought it very desirable that a classified catalogue should exist, distinguishing the vari-

4. New boundaries

ous schools of painting, and enumerating the masters and principal followers of each in historical order; a glance at which would show, not only what the gallery already contains, but what would be wanting to make such a collection complete (SCNG 1853: 791).

Notwithstanding the title of the *Plan for a Collection of Paintings, Illustrative of the History of the Art*, the authors noted in their introduction that it would also be desirable to acquire drawings, intarsia, painted glass and tapestry. However, this was not reflected in the *Plan* itself, and bore no relation to future collecting at the National Gallery (Select Committee 1853: 793). The *Plan* constituted, peopled and characterised a particular story of art. The story was diachronic and focused on stylistic developments in painting, which were articulated through biographical accounts of artists and genealogical accounts of artists' influence upon one another (see Whitehead (2005b) for discussion of Gustav Friedrich Waagen's seminal 1853 essay, 'Thoughts on the new building to be erected for the National Gallery', which proposed a similar system, also limited to painting). In terms of display, this meant the physical ordering of works to represent both the periodised oeuvres of key artists, such as Raphael, and the relationships of tuition and influence between different artists, between 'schools', and so on (for a discussion of the use of the term 'school' at the National Gallery, see Whitehead 2005a: 24). After a preamble explaining its purpose, the *Plan* is made up of two columns (Fig. 5), the principal of which simply lists the 'Schools' of painting such as Florentine, Venetian, Umbrian etc. (and the geographical articulation of the *Plan* gives it a multilayered cartographical operation). Within Schools are listed the artists who belonged to them in roughly chronological order, incorporating notes on master-student relations. Alongside these lists, a second column gives occasional explanatory remarks pointing out the characteristics of certain schools or groups of artists and their stylistic similarities with, and differences from, others. For example:

103

The Sienese School, in its earlier character [i.e. from the early thirteenth century], was remarkable for a religious tendency, not merely as regards the choice of subjects (which were everywhere of the same kind), but in a certain devotional fervour of expression; resembling, in this respect, Angelico da Fiesole, and also the painters of the Umbrian School. The works of all these painters, though conveying the impression of deep feeling, do not exhibit that variety of form and study of nature which are conspicuous in the Florentines generally, to whom Angelico da Fiesole is thus to be regarded as an exception. With the Sienese, the prevailing tendency of feeling referred to involved a certain limitation in the forms and the character of heads (SC 1853: 795).

It is apparent that the scheme was concerned with form and not with content in painting, with authorship and not with social context, and with a history of the production rather than of the use or social roles of works of art (and all of these might now be seen as false dichotomies). In the above quotation the issue of subject matter is entirely subsidiary to the rather minute deliberations on stylistic differentiation and accounts of exceptions to the rules, while there is no attempt to consider the relationships between the production and consumption of paintings and social, political, religious or economic contexts of thirteenth-century Siena. Notably, the *Plan* is also a list of artists and not of works of art. This functions to bestow importance on the identity of the artist himself (for the artists listed are mostly male) as subject and catalyst of intellectual evolution, while also making it possible for paintings within the gallery to act as signifiers of their authors. In so doing, the *Plan* corresponds to a long historiographical tradition based on the comprehension of the past through the study of great men (comprehending authors as varied as Plutarch, Paolo Giovio, Giorgio Vasari and Thomas Carlyle), although the biographies of the artists involved in the *Plan* are limited to their place within trajectories of tuition and influence. The emphasis on

4. New boundaries

artists rather than works of art also responded to a practical imperative, in that it meant that different galleries could represent the same history of art by each collecting different 'specimens' of the same artists' work, thus ensuring the feasibility of executing the *Plan* within the context of the competitive European market for 'Old Masters'.

Eastlake's approach to the question of quality was somewhat innovative; the scheme included early works, conventionally perceived to be of a lower artistic quality (Steegman 1950: 61-74; Hoeniger 1999), where they were seen to illustrate the historical narratives discussed above. This is not to say that quality was an unimportant criterion, but that it was ultimately subordinate as a structuring principle to a certain kind of comprehensiveness in historical ordering. Indeed, the rhetoric of comprehensiveness in a genealogical history of art was important in justifying the acquisition for the National Gallery of mediaeval paintings such as Margarito d'Arezzo's *Virgin and Child Enthroned* of 1255 (Fig. 6, purchased during Eastlake's directorship in 1857), conventionally seen as 'primitive' and generally undesirable. (Margarito d'Arezzo is one of only six artists listed in the *Plan* under the heading 'early Italian specimens influenced by Byzantine art'.) However, Eastlake's admission of early mediaeval painting was rationalised through the coherence of the system and not in relation to prevailing notions of taste. In this sense he was careful to point out that such objects were not to be admired so much as understood: their study, as he put it, was 'addressed to the understanding rather than the imagination' and was connected with 'a certain sort of erudition' but not with taste (SCNG 1853: q. 6466). Consequently, only a few 'specimens' were required to make the system work:

> I think it is most desirable to collect works of the early Italian masters, but I think it should be done with discretion and discrimination. I have ... seen many works of those painters full of affectation and grimace, such as would not be tolerated in a modern artist, nor should they

be admired in any artist; therefore, to form a collection blindly and indiscriminately, without taste, and even an artist's taste, would not, I think, be judicious (SCNG 1853: q. 6480).

The particular stories of art which Eastlake and Wornum proposed to tell also isolated paintings into a discrete narrative, distinguished from other forms of material culture and from architectural and socio-historical contexts. The notion of the *purpose* of historical organisation is particularly important. The authors made it clear that the hypothetical collection of paintings they were sketching *could* be studied in different contexts, for example the 'connection' of the paintings with 'Religion, History, Poetry, Natural History ... Physiognomy, Costume and other facts'. However, for Eastlake and Wornum these were 'general uses', subsidiary to the 'special purposes' of the collection, which were to represent the development of 'well adapted and durable technical processes' and style, understood as 'artistic merit, considered in relation to periods and schools [and] the illustration of the connexion between various modes of representation' (SC 1853: 792).

Newton's archaeology

In 1853, Charles Newton was Acting Consul at Rhodes, having resigned from his post of assistant in the British Museum's Department of Antiquities in 1852. His links with the Museum were still very significant, for alongside his consular duties he was authorised to acquire and excavate objects in the British Museum's interests (Cook 2004). Newton would later take up the Keepership of the newly formed Department of Greek and Roman Antiquities in 1861. From Rhodes, Newton wrote an essay of about 10,000 words as a letter to the Chairman of the Select Committee. This was entitled 'On the Arrangement of the Collection of Art and Antiquities in the British Museum', and one of its objects was to weigh up the distinction implicit in its title. It is likely that Newton was encouraged to engage in this not inconsiderable labour by former colleagues at the British Museum, most probably Edward Hawkins, the current Keeper of the Department of Antiquities. The essay was erudite and involved a carefully argued plea not to dismember the antiquities collections of the British Museum. He did not address the issue of the amalgamation of the National Gallery's collections with those of the British Museum directly, but confined himself:

> to the question, whether, in the event of an entirely new arrangement of our national collections, the antiquities now at the British Museum ought to be considered as one entire collection, or whether, as has been recently proposed, the finest specimens only should be transferred to a new museum of art, the rest of the antiquities being left where they are at present, or distributed in other museums, of which the formation is now contemplated.

This was, as Newton noted, a question 'of the greatest moment' (SCNG 1853: 772).

While Eastlake opted to segregate painting, Newton was concerned with uniting what he saw as three classes of mate-

rial culture: 'Monuments of Fine Art, or productions of what are called the Fine Arts'; 'Inscribed Monuments' of any material and 'Monuments of Handicraft, or production of the useful and decorative arts'. In fact Newton's letter was an appeal to conserve the heterogeneity of the British Museum collections in any future large-scale redevelopment of the national museums, for only through the 'felicitous combination of the monuments of many races' could 'a vast scheme of historical relations [be] suddenly disclosed and demonstrated' (SCNG 1853: 781).

In discussing material culture Newton uses relatively conventional classifications, such as 'fine art', and reproposes certain entrenched narratives, such as the Winckelmannian identification of Hellenistic sculpture as the apex of human achievement in art which was followed by a gradual decline, along with a conventional 'organic' metaphor wherein 'the art of schools and races [is], like the life of the individual, subject to a certain law of growth, maturity and decay' (SCNG 1853: 780-1). He went so far as to refer to the 'ennobling' effect of viewing works of art upon visitors (ibid.: 781), which was a frequent refrain of policy makers and politicians interested in the moral 'improvement' of the 'masses'. Aesthetic appreciation is in fact a primary concern throughout the essay, for example in his attempts to 'determine the relative merit' of objects (ibid.: 775), or his consecration of discrepant objects such as coins as 'worthy to be studied as works of art' ('coins present to us', he said, 'a piece of bas-relief, or rather of mezzo rilievo') (ibid.: 777). However, as he put it, 'we cannot appreciate art aesthetically unless we first learn to understand its meaning and motive' (ibid.: 780). For this, he explained, displays and the categories of objects they included had to be relational. For example, Assyrian relief sculptures and cylinder seals belonged respectively to the categories of fine art and handicraft, and indeed both belonged to the class of inscribed monuments, but, as Newton pointed out:

> The same peculiar style of art, the same figures and groups, the same cuneiform characters which we find in

109

the larger friezes, reappear on a reduced scale in the cylinders and seals; one system of mythography and of historical record pervades the whole of the art. (ibid.: 773).

There is, then, a clear appeal to attend to the relatedness of apparently different things. For Newton the rationale behind this approach was the greater understanding of what he called the 'meaning and motive' of objects, for which different sorts of objects needed to be available for cross referencing. 'The vase-picture,' he instanced, 'will show us how a sword or any other piece of armour was worn and used; in the adjoining collection at the British Museum we may find the sword itself' (ibid.: 779). Vases had further relational uses:

We know from Pausanias, that the subject of the composition in the eastern pediment of the Parthenon was the Birth of Pallas Athene; but the central figures in that pediment having been completely destroyed, the character of the original composition would be entirely a matter of conjecture, were it not that this mythic scene is represented on a number of fictile vases, of which the British Museum possesses one of the most perfect specimens (ibid.: 774).

This also represents the importance of understanding objects through their subject matter. Indeed, much of Newton's letter was an appeal to the primacy of *meaning* as an interpretative key:

How much, for instance, has the interest of the figure in the Gallery of Florence, commonly called 'The Listening Slave,' been enhanced since this figure has been recognised as part of a group representing the flaying of Marsyas by Apollo[?] (ibid.: 775).

A related concern was representation. In discussing Egyptian 'colossal statues' Newton pointed out that 'to understand what these specimens of sculpture and of plastic art *represent*, we

110

must study the inscriptions' (emphasis added; ibid.: 773). This emphasis on representation in the sense of content was quite absent from Eastlake and Wornum's *Plan*. Newton continued, relating this principle to display:

> ... These inscriptions being in the hieroglyphic character, we are at once led from the study of the monuments of art to the study of inscribed monuments, and it is therefore found convenient to arrange the hieroglyphic texts side by side with the statues.
>
> This is an arrangement which I do not imagine that any one would wish to disturb (ibid.).

Connected to the content and subjects of representation was iconography. This too was absent from Eastlake and Wornum's scheme of historical understanding. Here Newton turns his attention to 'Christian Art':

> If we would comprehend and thoroughly appreciate such designs as the Last Judgment, in the Sistine Chapel, and other great religious paintings of the same period, we must study the language of mediaeval art generally, and trace back the progress of iconography through a long series of monuments from the first centuries of Christianity ... (ibid.: 776).

This formed a different justification from that given by Eastlake, who was concerned with the evolution of style, for the admission of objects into collections which did not fit with prevailing contemporary notions of taste:

> [we must include] in our survey much that is unattractive to the eye for the sake of the information which we thus obtain (ibid.).

Newton's reflection on 'Christian' art is also indicative of the absence of demarcation in his scheme, which represented a

'continuous chain of tradition which connects Hellenic and Christian art, and traverses the vast interval of time between Phidias and Raphael' (ibid.: 779). An earlier theoretical essay of Newton's, entitled 'On the Study of Archaeology', forms a useful key to understand his letter to the Select Committee. It was delivered as a 'discourse' at a meeting of the Archaeological Institute in 1850 – a different, and possibly more allowing, political context from the major public enquiry that was the Select Committee. In this discourse, which was subsequently republished as an essay, Newton sought to define the purpose of archaeology, and its possible objects of study:

> The method of interpretation which the classical Archae-ologist has applied to Greek Art is well worthy [of] the attention of those who undertake the interpretation of Christian Mediaeval Art (Newton 1880: 23).

This also relates to Newton's specific interests in religion, and art as 'figurative and symbolic language for religious uses' (Newton 1880: 21). He explained:

> As the Greeks have bequeathed to us not only a Mytho-logy, but a Mythography [i.e. the expression of myth in art], so in the painting and sculpture of mediaeval Chris-tendom we find an unwritten Theology, a popular figurative teaching of the sublime truths of Christianity, blended with the apocryphal traditions of many genera-tions. The frescoes of the great Italian masters, from Giotto to Michael Angelo, the ecclesiastical sculpture of mediaeval Europe generally, are the texts in which we should study this unwritten theology (ibid.: 23).

Scholars of such art were also at an advantage for Newton, because 'Christian Iconography is at once more congenial, and more familiar to us, than Greek mythography' (ibid.: 24).

The significance of these statements lies in their attempt to carry over the interpretive methods developed by classical ar-

chaeologists to the study of (what we would now call) mediaeval and renaissance art. He perceived no divide or *caesura* which justified the segregation of objects or the association of different knowledges with them. In this context he also challenged the 'invidious line of demarcation between the fine arts and the useful arts, as if there could be no alliance between them' (SCNG 1853: 778):

> Everyone conversant with the history of Art knows that Architecture, Painting and Sculpture, as they are naturally connected, so have in all times been more or less associated, and that the divorce by which, in modern times, they have been parted, is as exceptional as it is to be deplored (Newton 1880: 33).

The 'invidious line of demarcation' was, of course, one which was being drawn at the time through the gradual development of the Museum of Ornamental Art, which would become the South Kensington Museum in 1857; it is a line which can easily be seen as the introduction or consolidation of a cartographical border. In another lightly veiled criticism of the museum endeavours of Henry Cole and his staff, Newton *did* attempt to push his argument to logical extremes in trying to identify what might, for him, form a hypothetical discrepant object – the steam engine – with which to force a boundary:

> I would submit that the miscellaneous antiquities of the Greeks, including all of their industrial products, should be exhibited in combination with the finest models of ancient art; and I conceive that, thus combined, they would yield a far more valuable lesson to the modern artisan than if banished to an industrial museum. If indeed the ancients had bequeathed to us a series of specimens of steam-engines and other instruments which might serve to show the progress of mechanical science, it would become a question whether such objects ought to be placed in a museum of art and of historical documents (SCNG 1853: 779).

113

Later on in the decade a display of machinery – which came to include steam engines – was indeed developed at the South Kensington Museum, whose purported aim of improving manufactures imposed a connection between science and art. This connection was embodied not only in the proximity of collections of scientific materials and art objects, but also in the new technologies used within the fabric of the Museum's building in the 1860s. This cartographical relationship of science and art, born of a political imperative, did not endure for long. In 1909 the Science Museum was established as an independent institution, after decades of separate management similar in some senses to the way in which the British Museum initially housed both natural history and antiquities collections. This comes back to the notion of the perceived usefulness of museums' maps of knowledge for users, for those who could make sense and benefit from connective visions of art and science at the South Kensington Museum or natural history and antiquities at the British Museum (God's work and man's, as it was sometimes understood) were, in the later nineteenth century, too few to warrant the conservation of outdated epistemologies.

Newton concluded his essay by recognising the perceived distinction between 'archaeological' and 'artistic' concerns, and perhaps some of the stereotyping which came with this distinction:

But it may be said that I have dwelt too exclusively on archaeological considerations; that the question before the Committee of the House of Commons at this moment is the formation of a Museum of Art, by which the taste of the English people may be educated and elevated, not the arrangement of materials for the use of the historian and the scholar; that the accumulation of objects distracts the eye and confuses the uninformed judgment by the simultaneous exhibition of heterogeneous objects and styles of art; that archaeological research and aesthetic culture do not go well together; and that it is better to make a kind of *florilegium* or selection of specimens for a museum of art,

so as to separate the beautiful from that which, being simply curious, is fit only to be studied through the spectacles of the antiquary (780).

In 1853 Newton's letter had conservative purposes in keeping together the British Museum's collections of antiquities, but in principle his suggestions for the ordering of knowledge involved a potentially vast relational scheme in which neither the age, provenance or type of object formed grounds for segregation. Taken to its logical extreme, Newton's museum would subsume the collections of the nascent South Kensington Museum (possibly barring the steam engines) and the National Gallery, subjecting all objects to the same regime of interpretation based on the notion that through socio-historical contextualisation and understanding of iconography and meaning, visitors could proceed to aesthetic appreciation. Art historians, in this scheme, would not be a separate group from archaeologists, but would instead together form a single community of practice, and all of those with an interest in the material culture in question (including artists and the general public) would 'meet on common ground':

> In reply to objections which may be raised against the combination of works of art and of historical antiquities in the same museum, it may be observed that museums are designed for the instruction and recreation, first, of the general public, secondly, of the artist by profession and of the student of art; and thirdly, of the archaeologist and historian.
>
> Why should not all these classes meet on common ground? In what respect do they hinder each other's study and enjoyment? (781)

The emerging figure of the art historian, typified by individuals such as Charles Lock Eastlake, is notably absent here and appears to be subsumed under the 'class' of 'archaeologist and historian', whose purview basically comprehended everything

that was man-made. As he put it in 1850, drawing on the dictum of Terence, the motto of the archaeologist should be:

HOMO SUM, HUMANI NIHIL A ME ALIENUM PUTO ['I am human, so nothing of human concern is foreign to my interests'] (Newton 1880: 35).

For Newton this bore directly on the project of archaeology, which he couched in explicitly museological terms in two instances: firstly by referencing the language of museum actions, such as collecting, and secondly by drawing an analogy between the developing discipline and the Great Exhibition of 1851:

The purpose and function [of archaeology is] to collect, to classify, and to interpret all the evidence of man's history not already incorporated in Printed Literature (ibid.: 2).

And:

The task which England has undertaken for 1851 is an Exhibition of the Industry of all nations at the present day; the object which Archaeology would achieve if possible is not less than the Exhibition of the Industry of all nations for all time (ibid.: 35).

Notably, ideas about display similar to Newton's circulated at the British Museum. A redisplay of the Graeco-Roman sculptures in the middle of the 1850s involved a thematic and not a chronological, arrangement. The principle was, as the officer Edmund Oldfield put it:

To make them the means of illustrating, as far as possible, the religion, the social life, and also the iconography of the ancient Greeks and Romans; that is to say, we divide them first of all mythologically, giving up one apartment to the Olympic deities; another to the other

116

ideal figures of less mythological rank; and then a third to the representations of human life; whilst a fourth apartment is appropriated merely to minor monuments, altars, candelabra and such like objects. We thought that would on the whole be a means of furnishing instruction to the archaeological student, which could not be obtained practically in any other way (SCBM 1860: 1963).

This was, in fact, something of an experiment, and it was only admissible because of the perceived impossibility of determining the dates of the Graeco-Roman sculptures, and hence the difficulty of organising them in the normally *de rigueur* chronological sequence.

In this section we have seen Charles Newton develop a very different approach to the understanding of material culture advocated in Eastlake and Wornum's *Plan*. In the latter, style is the predominant instrument of organisation of material culture and, simultaneously, the primary interpretive key and object of study, and paintings are identified as a hermetic group within the world of material through which this historiographical project could be pursued systematically. Newton was not uninterested in style, and developed concerns pertaining to chronological arrangement which, if translated into display, would be superficially similar in this principle to the arrangement of paintings suggested by Eastlake and Wornum. But style was of secondary interest to Newton, whose primary object of study was *meaning*: this, with its various components as he saw them (representation, content, contextual analysis, iconography) formed the interpretive key, and everything human-made could throw light upon this, suggesting that everything should be displayed relationally. However, the two schemes explored so far had two commonalities: in each, subjective aesthetic standards were at play; and in each the ultimate purpose of study, and of display, was the comprehension of the object as object, rather than the object as lens with which to survey the history of humanity. We will now turn to another proposal in which the 'object-as-lens' idea was played out.

Ruskin's 'pots and pans' and the
Pagan and Christian museums

The Select Committee of 1853 recommended, in its report, that land at Kensington should be purchased for the removal of the National Gallery. It stopped short of advocating the amalgamation of collections, suggesting instead that this question be referred to a Royal Commission (SCNG 1863: xvii). This, while it recognised the momentous nature of the issue (Royal Commissions are independent of government, typically dealing with contentious issues, and report directly to the monarch), also delayed the work of reorganising knowledge in practice. While some of the discussions of the Select Committee fed into identifiable reforms (such as the development of a new management structure at the National Gallery in 1855), others were not attended to, and the issue of the removal of the Gallery and the amalgamation of collections was still being discussed in Parliament in 1856, when a motion was put to establish a Royal Commission along the lines of the suggestion made in 1853. Lord Ellesmere – high up in the constellation of aristocrats who were also senior politicians and patrons of the arts – suggested that the antiquity/art boundary still needed to be policed:

> [in a proposed new National Gallery] will [we] make any distinction between works of excellence as models in an artistic sense, and those in which antiquarian and historic considerations predominate – between Greece and Rome, and Egypt and Nineveh? (Hansard 1856: CXLII, 2102-3)

The motion to appoint a Royal Commission was passed, confounding Benjamin Disraeli's attempts to force through a bill for the development of a museum/ school-science/ art complex similar to that previously proposed by Prince Albert, which would be oriented towards the education of artisans for the benefit of British manufacture and the national economy. Over

118

4. New boundaries

this complex of institutions, a national gallery of paintings would preside 'as a crowning and consecrating ornament of the scene, the Gallery of the Nation' (Hansard 1853: CXLII, 2146). The resulting Commission was appointed in 1857 'to determine the site of the New National Gallery, and to report on the desirableness of combining with it the Fine Art and Archaeological Collections of the British Museum' (RC NG 1857: iii). It is here that the idea for reorganising knowledge in a radically different way emerged, eradicating the need to distinguish between art and archaeology, or between art works and antiquities. This idea involved the reconstitution of the national collections into two museums of art *and* archaeology – one 'Pagan' and the other 'Christian', and its supporters included the famous, opinionated author and art critic John Ruskin, who was called to witness, Antonio Panizzi, who was the Principal Librarian (and thus the principal officer) of the British Museum, and Charles Newton, who was prevailed upon to revise the scheme which he had advanced in 1853. Panizzi claimed that the idea had originated with the recently deceased archaeologist and British Museum trustee William Richard Hamilton (SCBM 1860: q. 284). In the context of the cultural field, the proposal represented a *subversive* strategy, for none of the individuals who promoted it stood to lose authority or status.

For Ruskin, the boundary between the two museums was the birth of Christ, meaning that the Christian museum would also contain Islamic art – because, as Ruskin noted, 'it seems to me that the history of Christianity is complicated perpetually by that which it was affecting' (RC 1857: q. 2488), although he did admit discrepancies, instancing 'all of the art of a nation which had never heard of Christianity, the Hindoo art and so on, would, I suppose, if of the Christian era, go into the Christian gallery' (ibid.: q. 2491). This is a religiocentric and indeed christocentric orientation for the organisation of material culture, but it permitted multiple foci, including, for Ruskin, sculpture, painting, architectural drawings and models, iron work, ceramics and woodwork; indeed, when pressed, Ruskin noted that a new national gallery should contain:

Everything, pots and pans, and salt cellars and knives (RC NG 1857: q. 2481).

Although Ruskin also emphasised the importance of classification and the inclusion of inferior specimens of art, his interrogative focus was quite different from Eastlake's or Newton's. As he put it:

> One of the main uses of Art ... is not so much as Art, but as teaching us the feelings of nations. History only tells us what they did. Art tells us their feelings, and why they did it: whether they were energetic and fiery, or whether they were, as in the case of the Dutch, imitating minor things, quiet and cold (RC NG 1857: q. 2437).

He went on:

> [A country] may be urged by an ambitious king to become a warrior nation ... and its character at that time may materially depend upon that one man, but in its art *all* the mind of the nation is more or less expressed: it can be said, that was what the *peasant* sought to, when he went into the city to the cathedral in the morning ... that was the sort of picture he prayed to. All of which involves infinitely more considerations than common history (original emphasis; RC NG 1857: q. 2475).

It is clear from this that Ruskin saw art objects as inherently documentary and thus useful for the study of topics beyond themselves. While to some extent this is romantically oriented, particularly in the notion that different peoples have inherent characteristics which are revealed by art, it also recognises the wider social network in which the production and consumption of art was situated, for example in the idea that the interpretational value of a religious painting resided in its location in a cathedral, in its relation to a viewer, and in its use within social and religious practices. This is a very different history of ob-

jects from those we saw earlier which focused on stylistic development, and the development of 'meaning'.

Curiously, Ruskin did suggest a further boundary which would surely have disrupted his scheme. This boundary related to quality and to his perceptions of the different capabilities for understanding art of uneducated people:

> It would seem to me that all that is necessary for a noble Museum of the best art should be more or less removed [from the centre of London], and that a collection, solely for the purpose of education, and for the purpose of interesting people who do not care very much about art, should be provided in the very heart of the population, if possible, that pictures not of very great value, but of sufficient value to interest the public, and of merit enough to form the basis of early education, should be collected in the popular Gallery, but that all the precious things should be removed into the great Gallery, where they would be safest, irrespectively altogether of their accessibility (ibid.: q. 2459).

Notably, the removal from the centre of London of the 'great' gallery was intended by Ruskin to encourage only 'those who could make a real use' of it to visit (ibid.: 2460). This is not so much a separation of knowledges, but a separation of publics as imagined visitors, with different amounts of cultural capital. The idea of 'great' and 'popular' galleries would appear to conflict with his idea about all-encompassing Pagan and Christian museums on two counts: firstly, by making qualitative distinctions between objects, working to consecrate some at the expense of others; and secondly, by appearing to suggest that the 'popular' Gallery should contain only paintings.

Nevertheless, as stated, the Pagan/ Christian demarcation was an idea shared by others, and this was explored more thoroughly in a Select Committee enquiry into the British Museum in 1860, in which, notably, demarcations between nature and culture were also tested to ascertain the desirabil-

ity of removing the natural history collections, which would eventually lead to the establishment of what we now know as the Natural History Museum in 1881. This debate had a religious aspect, for the issue was, for many, the connection or disconnection of God's work from that of mankind. While there is no space to explore this here, it is notable that such fundamental epistemological binaries were all in play at once: nature/culture; divine/ human; art/ antiquity; and Pagan/ Christian.

In 1860 Panizzi clarified that the Pagan/ Christian demarcation was not simply one of convenience but rather it obtained because 'the feelings which inspired Greek artists were different from the feelings which inspired Christian artists, particularly in the fine time of the fine arts in Italy.' He went on, 'I do not think that the sculptor of Venus and the painter of the Madonna were moved by the same feelings' (SCBM 1860: q. 357).

Richer than his own evidence, however, were the further considerations of Newton on the question of amalgamation, for Panizzi had asked him to send another letter (Newton was now in Bodrum), which was reproduced in the Report of the Royal Commission alongside the one he had sent to the Select Committee of 1853. Although Newton noted that his concern was 'not what theory of a museum would be possible, were time, space and money of no moment, but what is practicable and expedient' (ibid.: 166), his considerations were nevertheless characteristically theoretical, noting that the 'line of demarcation' between Pagan and Christian museums 'may be fixed without difficulty by the observance of a very simple rule':

> In whatever case a Christian emblem or motive can be clearly recognized in a work of art, it should be at once assigned to the museum of Christian art. Practically, the observance of this rule will make the reign of Constantine the Great the chronological limit of the art of antiquity, though isolated instances of antiquities are occasionally to be met with of later date (ibid.).

4. New boundaries

In practical terms this meant that the British Museum would become the repository for pagan material culture while the other holdings of the museum would be moved out to a new Museum of Christian Art. The latter would also contain the paintings of the National Gallery and the decorative art collections (however loosely the term was used) currently being built up at the South Kensington Museum (Newton was perturbed by the potential rivalry involved in two institutions collecting Christian Art) (ibid.: 166). The idea was novel, but nevertheless reproduced canonical affirmations – the national collection of paintings would be the 'prominent feature in the whole design' of the Christian Museum, 'just as in any museum of pagan art the sculpture gallery should always be the paramount point of interest, as presenting the highest manifestation of the power of the ancient artist, and the clearest expression of the art motive' (ibid.).

Newton tested this scheme with a number of boundary objects. Firstly, the numismatic collection he proposed to keep together at the British Museum, for the Pagan/ Christian demarcation criterion, if observed, would mean that 'the Roman Imperial series would be abruptly severed from the subsequent Byzantine', and this 'dislocation of numismatic sequences would be a hindrance to the student' (ibid.). The solution he proposed was to develop a 'skeleton' collection of coins in the museum of Christian art whereby a scheme of relational display could be pursued without omissions. Next, illuminations were (as already seen) commonly contested objects and Newton proposed that they should remain at the British Museum because 'inseparable from the manuscripts of which they form the marginal ornament', which, in turn, were inseparable from larger collections such as the Harleian Library. To get around this problem Newton suggested forming a collection of 'detached specimens' for the Christian Museum. Another contested object was armour, the most significant collection of which was at the Tower of London. As Newton pointed out, this had been instrumentalised in the pursuit of quite different knowledges:

> This class of antiquities, being an essential part of military history, has been, both in France and England, combined with a museum of ordnance (ibid.: 167).

However:

> In cases ... in which armour has been decorated by some celebrated metallurgist like Cellini, its interest as a work of art far transcends its military interest, and such objects may therefore be fairly assigned to a museum of art (ibid.).

The last boundary object Newton considered was the ethnographical collection at the British Museum, which he proposed to remove because it did not fit with the project of history as he saw it:

> The miscellaneous mass of objects which [the collection] contains are for the most part the product of uncivilised races in modern times, and therefore more legitimately belong to a museum of industrial products than to one of art and antiquities.
>
> An ethnographical museum should illustrate certain results of modern geographical discovery with special reference to commercial wants and interests ... The purpose of such a museum is rather to exhibit certain phenomena of the present age, than to rescue from oblivion the relics of the past: it deals with existing races and their products – with things ephemeral rather than things monumental; the information which it supplies is connected with prospective enterprise rather than with retrospective researches (ibid.).

With this, ethnographic material was relegated and excluded from processes of consecration associated with art and with historical study, even though some ethnographic objects had

been collected by Hans Sloane in the early 1700s, and were thus, arguably, historical in themselves.

The Report of the Royal Commission of 1857 was not favourable to the idea of uniting collections or purchasing land elsewhere for new museums, but the commissioners had disagreed and the credibility of the report was questioned (see Whitehead 2005a: 159-62). The matter was not resolved, and in fact, the Pagan/ Christian demarcation was still being argued over three years later during a Select Committee on the British Museum, where figures such as Henry Cole and Antonio Panizzi replayed their arguments. It should not be thought, however, that all British Museum staff approved of the scheme: the Keeper of Antiquities Edward Hawkins, for example, did not want to see mediaeval antiquities removed, although he would happily have shed the ethnographic and Mexican materials (SCBM 1860: q. 1576-7, 1582); his assistant Edmund Oldfield held similar views (1997). A further challenge to the Pagan/ Christian demarcation came from Austen Henry Layard, the celebrated excavator of Kuyunjik, Nimrud and Babylon whose finds were housed at the British Museum. When asked whether mediaeval antiquities should be retained with other antiquities he replied:

> First of all, one must define what mediaeval art is, and where the line is to be drawn. I certainly have great difficulty saying where it begins, and I suppose 20 different people would give 20 different opinions upon that point; I think you cannot draw the line. The moment you have a museum which represents what I think it ought to represent, the history of civilization and of the human mind, you can draw no line, and I should continue art up to the present moment in such a museum (ibid.: q. 2544).

The parameters of this hypothetical museum appear vast, and Layard advocated a relational scheme similar to Newton's, explaining that he would arrange large objects in central halls

with satellite rooms, so that the monumental and the minute could be interrelated. Like Newton, though, he wanted to see ethnography cast out and illuminated manuscripts retained in a library. Also, like Newton, he rejected the distinction between fine and decorative art (ibid.: q. 2617). The Committee sought to clarify this by making use of the discrepant object of armour: was this art? Layard replied, in a circular fashion:

> I should call it so, if it deserved to be viewed as a work of art; but I should not call a mere old piece of armour, because old, a work of art (ibid.: q. 2618).

This did not imply the exclusion of armour of any description, however, for its historical value alone rendered it a valuable inclusion for Layard, who, like Ruskin, distinguished between art and other historical objects but did not advocate their segregation from one another. The paintings of the National Gallery Layard proposed to house in an additional storey at the British Museum (ibid.: q. 2551). Other than the ejection of the ethnographic collections, the only line he could draw was that between the South Kensington Museum and the British Museum, whose respective mediaeval collections did not 'embrace the same objects':

> The British Museum I look upon as a great museum, containing a history of human civilization and of the arts; Kensington Museum I look upon as a collection of objects useful for the instruction of the manufacturers of this country, and anybody who engages in art pursuits (ibid.).

In this, Layard reproduced the distinction which Henry Cole advocated publicly, although as seen in Chapter 2, the South Kensington Museum's mission shifted according to opportunity and the use of the term 'manufacture' was loosened strategically when required.

Before this Committee, Eastlake contributed again to the debate on the organisation of collections, this time defending

more aggressively his project of segregating and isolating painting as a discrete category of material culture, and in so doing playing out his conservative strategy within the field of culture. After five years in post as Director of the National Gallery he could afford to be more open in his convictions and to play a game less subtle than he had in 1853 with the publication of the *Plan for a Collection of Paintings*. 'I do not,' he stated, 'think it would be of much practical use to have an enormous museum containing everything' (2675), for the vast potential for establishing knowledge relations was ultimately disabling:

All works of art may be compared together, and art may be compared with nature; and there is no end to the analogies which you might wish to see established and made accessible with the least possible difficulty; but I think that, practically, it would tend to very little purpose to have a museum which would embrace all works of art (ibid.: q. 2674).

Again, the Committee tested his exclusive scheme for discrepancies, pointing out that some of the engravings which East-lake wanted for the National Gallery would have been produced by the same individuals whose metalwork might be found at the British Museum. The 'keeper of the mediaeval department in the British Museum,' explained the chairman of the committee, 'might have very great reason to complain if prints executed by the same class of workmen, as some other of the mediaeval works, were separated from one another, as they both illustrate each other (q. 2680-1). Eastlake's response was firm – materials should be separate:

I really do not see any objection in that; such an arrangement would lead one to desire that the paintings of Michael Angelo and his architecture and sculpture should all be placed together (ibid.).

Competition

It is now time to consider how these different proposals for knowledge relations – for cultural maps with drawn boundaries – competed with one another, and to assess which of them prevailed, and in what measure, and which failed. Ruskin's proposal for 'Pagan' and 'Christian' museums is especially interesting in the context of boundary work. On the one hand its boundaries are immense, as Ruskin proposes the use of a uniform approach to objects normally seen to be of vastly different type (e.g. paintings and 'pots and pans'). On the other hand, within this broad territory he argues for certain divisions of knowledge based on a specific 'demarcation criterion' (Fuller 1993: 126-7). It can be argued that demarcation criteria are invariably complex and inherently political, and the use of the Pagan versus Christian criterion is a clear example of this, as, for that matter, is the more conventional criterion of 'art' versus 'non-art'. In this alone the acts of differencing within disciplinarity are problematic.

However, the museological proposals which this chapter has explored were also competitive. One theory of discipline is that it is a principle of limitation. In the words of Amariglio, Resnick and Wolff (1993: 150-1), 'a discipline arises in the course of struggles to limit the discourses involved in the production of formal knowledge'. They go on to discuss that while limitation may arise from agreement, it more often results from the silencing of discourses. In this context it could be argued that Eastlake's emphasis on a dislocated and discrete history of painting, itself organised around an overriding notion of style in exclusion of other interrogative foci, is a clear attempt to limit discourses; it is reductive boundary work as opposed to the expansive boundary work attempted by Newton and above all by Ruskin. It might also be argued that circumstances (political and other), enabled the silencing of the sorts of discourse in which Newton and Ruskin participated, concerning the integration of bodies of material culture within the museum. As stated earlier, to a certain extent their silencing was

adventitious, contingent upon opportunities such as the pur-
chase of land at Kensington, against which many MPs voted,
whether for reasons based on conviction or simply to defeat
government it is difficult to discern (in either case the MPs
were, for the duration of the debate and the vote, actors within
the museum world). Arguably, though, these contingencies co-
existed with intellectual reasons for the silencing of discourse.
However, it is difficult to find any open acknowledgment of
such reasons in contemporary writing, so they must be under-
stood to be speculative.

For example, the integration of paintings into wider mu-
seum collections would have weakened the crucial
nineteenth-century discourse about their transcendental and
moral agency, which was of great concern to policy makers in
relation to the perceived need to 'improve' new electorates. If
placed alongside 'pots and pans, and salt cellars and knives' –
or even in the same building – paintings might have become
just another category of material culture, and this could have
been difficult to countenance, given the importance of their use
within broader socio-political projects. Indeed, the intensity of
government attention to the management and development of
the National Gallery in the mid-nineteenth century was un-
precedented and has never been matched since: between 1848
and 1861 the National Gallery alone was the subject of no less
than five major government enquiries, involving the convoca-
tion of hundreds of witnesses and, as previously instanced, the
production of thousands of pages of material in report form.
This is an indication of the political investment in the collecting
and display of paintings in various contexts, such as the ongo-
ing project of electoral reform and cultural competition with
other industrialised nation states, whose galleries and collec-
tions were a constant reference point in the development of
policy in Britain (Whitehead 2005a: 12-16).

So far I have accounted for segregation. But why style rather
than meaning or context? There are a number of possible rea-
sons, all of which seem to interrelate on close analysis. For
example, the identification of style was a key determinant in

contemporary practices of attribution, meaning that there was a strong economic imperative involved in perfecting this intellectual practice, for considerable sums of government money (relatively speaking) were spent on paintings, which, if proven to be misattributed to one artist or another, could turn out to be the source of embarrassment both nationally and internationally (Robertson 1978: 84-7). Further, the focus on style hinged on the question of (largely) beneficial tuition and positive influence, which bears relation both with the importance of work and studio-based teaching and learning in nineteenth-century Britain (both in terms of the apprenticeship system and the formal education of 'artisans', for example at the Schools of Design) and with the broader teleological discourse surrounding the identity of Britain in relation to colonised others (Whitehead 2005b: 193). This is to suggest that wider contemporary values and concerns permeated new disciplinary practices, as discussed in Chapter 2.

Another of the benefits of the emphasis on style is that it de-emphasised content, helping to neutralise the encounters between working class visitors, who were seen as excitable and easily-led, and paintings with potentially dangerous subject matter. An example is the *Adoration of the Shepherds* (NG 232) bought as a Velasquez during the 1853 Select Committee proceedings (Fig. 7; attributed today to the Neapolitan School *c.* 1630). Perhaps because of the unidealised representation of figures and the sheer griminess of the scene, this painting was seen by some to represent a sacred subject inappropriately, in such a way as to debase visitors' morals and excite inappropriate feelings (and here one should consider all of the dark hints at mass action and popular uprising that such a view must have conveyed in 1850s Britain), the proposition being, as one Select Committee member put it:

> That the taste of the mass of the people, who frequent the National Gallery, and who are not used, or but little used to see objects of that kind [i.e. the subject matter] treated in the way in which they ought to be treated, is likely to be

4. New boundaries

deteriorated by having placed before them a very large picture treating a very sublime and very sacred object in a very low and undignified manner (SCNG 1853: q. 5400).

When quizzed about this controversial acquisition during the proceedings, the insistent appeal of some witnesses to the primacy of style as interpretive key effectively defused this controversy (Whitehead 2005a: 138-9). In a sense, the culturally problematic aspects of the painting in mid-nineteenth-century Britain were thus cleaned away by its siting within a museum context and within a museological system (McClellan (1999:16) discusses a similar act of purification in revolutionary France). This is indicative of a certain problem. On the one hand paintings were held up as quasi magical objects with agency all of their own, capable of exerting beneficial moral influence upon individuals (and particularly upon those who were seen to be most in need of it) (see also, McClellan 2003: 8; Roberston 2004: 4). On the other, the subject matter of historical paintings was potentially dangerous (for example, consider the question of morality in Greek mythology, or of religious doctrine in catholic imagery), and hinted at past and/or foreign societal mores and practices which would have been largely unacceptable in mid-century Britain and which policy-makers would have had no wish to promote, either inadvertently or otherwise. Given this tension, the adherence to style seems almost to represent a national strategy for understanding paintings – the imposition of a dominant 'anamorphic perspective' as Preziosi might put it (see Chapter 1) – in which subject matter and the social histories of paintings were effectively suppressed as 'dimensions of meaningful reference'.

5

Final thoughts

As noted, while defining the term 'disciplinarity', Messer-Davidow, Shumway and Sylvan (1993: 3) state:

> To borrow from Foucault, we could say that disciplinarity is the means by which ensembles of diverse parts are brought into particular types of knowledge relations with each other.

The previous chapter has explored events which can be seen from a number of perspectives: power plays within the cultural field, the struggle for resources and legitimacy and, again, the permeation of museum actions by wider political and cultural forces, which I have attempted to show through the example of the primacy of Eastlake's model of a hermetic display of paintings. In a Bourdieuan context these events show, I would argue, that the specific type of struggle which the cultural field imposed upon actors implicated in museum actions in the 1850s was both territorial and cartographical in prompting people to represent worlds of objects and knowledge. We have also seen that museum representations – both those tested out notionally in debate and those which took the form of institutional practices like collecting or display – were often produced through co-operative activity, taking us again to the notion of the museum world appropriated from Howard Becker. Here, as discussed in Chapter 2, co-operative activity can be harmonious work towards a shared goal, as in Antonio Panizzi's interaction with Charles Newton with a view to persuading the government of the legitimacy of a particular set of knowledge

relations. It can also be marked by conflict, contest and nego-
tiation, through competitive boundary work or through the
actions of those who seek to impede particular museological
schemes, such as the MPs who, for their own private reasons,
voted against a new museum complex in which to refigure
knowledges.

Recalling the definition of disciplinarity as 'the means by
which ensembles of diverse parts are brought into particular
knowledge relations with each other' (ibid.), the last two chap-
ters have examined just some of the ways in which the
physical, institutional and public space of the museum allowed
individuals to marshal such ensembles of diverse parts (which
here can be understood to stand for aims, practices and mate-
rial objects) in specific ways, and to establish specific
knowledge relations unavailable through other means. In this
sense it is possible, as discussed in Chapter 1, to view museum
display, notional or real, as a form of theorising, through the
relations between 'diverse parts' one seeks to establish and the
boundaries one sets. In Chapter 1 I asserted that this form of
theorising is politically and circumstantially contingent, and I
hope the historical narrative provided in the second part of this
book has shown this in practical ways. Such theorising is also
potentially divisive, for in bringing together some objects
(physically, intellectually and territorially) it separates others;
in enabling some kinds of knowledge relations, it disables oth-
ers. To point out what may seem a banal example – the
nineteenth-century project of museum display, because of its
inherently spatial nature, privileged an archaeology and an art
history articulated through *objects*. What alternative histories
did this obscure?

The outcome of the debates about the rehoming and amalga-
mation of the national collections – the silencing of discourses
surrounding the integration of different types of objects, and
the segregation of painting and its interrogation in terms of
style – has been profoundly influential, providing the intellec-
tual foundations for the National Gallery in London and others
which were modelled upon it. The art history thus proposed

was one of products ('works' of art) rather than the processes (of production, siting and consumption) in which material culture can be situated. At the same time, the 'products' signified their makers in various ways (as being 'by' a certain artist, as 'belonging' to a certain geographical school, and so on), engendering an art history interested in human individuals and networks. Style, accounted for in terms of geography, chronology, tuition and influence, enabled the construction of a relational matrix whose workings predicate later practices of comparison in other historiographical media – the textbook, the slide lecture and the photographic library.

Lastly, we must consider boundaries – what is the relationship between the isolation of painting from other forms of material culture in the museum and the boundaries of disciplinary study? Simply put, painting was radically consecrated and invested with hyperbolic values; it was also seen to have transcendental agency. This obscured the possibility (a possibility which Ruskin recognised) that at the moments of their initial production and consumption, paintings were as instrumentalised, and as much of a contextualised, social object and cultural text as any that Charles Newton discussed in his writings. Indeed, Newton promoted a single mode of study – a single way of knowing – across material categories which others sought to bound and segregate. Had his type of cultural cartography been legitimised in the competition of the field, a different possible future for the study of the past might have emerged, dissolving developing differences between archaeology and art history. In this, all human-made objects in the broadest sense – from landscapes to pots and pans and paintings – could be apprehended as relational and documentary objects of study irrespective of the prominence and status of their aesthetic dimensions. This brings up a philosophical question: turning upon its head the social constructionist notion of art (in the spirit of provocation), is there any human-made object which is *not* art?

In this way the museum figures within emerging questions about the narrow foci of some forms of art history until rela-

tively recent decades (in particular that which deals with, and thus works to define, post-classical 'art'), and the invisible but tangible divides between what has been studied under the banners of disciplines such as art history, archaeology and others, such as anthropology. More recent endeavours in art history can to some extent be read as attempts to overcome the disciplinary boundaries implicated in historical museological discourse; for example, the New Art History has worked to recapture a sense of paintings as objects of social use rather than as transcendental objects, detached from everyday life, while the parameters of what is studied in art history curricula have broadened over the last decades to supersede the biographical and genealogical emphases typical of much nineteenth- and twentieth-century practice. Tracing links between historical museum practice and contemporary disciplinary practice is inevitably suppositional – especially if one considers the lack of unity within art history as a discipline which some have identified (Preziosi 1993: 216-17) – but this is not to devalue it in enabling new reflective understandings of both.

What has been examined in the last half of this book are different statements by different actors about two interrelated problems: how to manage material culture and what information it should be interrogated for. While the statements differ about the point of studying objects and which histories should be pursued, they involve certain commonalities. Firstly, they all insist on classificatory organisation, even when this is merely on a qualitative basis. Secondly, they frequently attempted to rethink the notion of value, so that objects seen to be of inferior artistic quality and taste were admissible within classificatory structures, which made them legible. Thirdly, simply engaging in classificatory work intended to be normative and governing can be seen as these actors' attempts (whether successful or not) to constitute a body of commonly accepted practices and a specific cultural hegemony – an attempt, in other words, to construct discipline intellectually, technologically and socially.

5. Final thoughts

Brian Harley, in his discussion of maps and power (2001: 51-82), talks of maps as forms of spatial knowledge presented impersonally or authorlessly, working to desocialise and survey space and thus to naturalise their own authority. The same can be said of the museum. Like the map, the museum is not a text like a television programme or a written text in which authors can control the temporal experience of the user. This is precisely because maps and museums are made of spatialised knowledge. Cultures are surveyed and in some way laid claim to, and authority over cultural terrain is sought (Barringer 1997: 19). Travel – geographical and intellectual – is referenced and surrogated and imagined visitors trace the journeys of curators in miniature. The practice of landmarking, whether through placing objects, lighting or other means, disciplines visitors into ways of knowing, and silences (another of Harley's concepts about the politics of cartography) are also constructive. One problem of the idea of the museum-as-map is that when in a museum it is rare that we can see or scan everything, as we might with a map laid out in front of us. Rather, we are *in* the map, and cannot see in front of us, around the corner, and upstairs, all at once. The map, as it were, unrolls before our eyes, under our feet. It is this contingency of travel through space and time (both in the local sense of our movement from one gallery to another and in the wider sense of our movement from one century or continent to another) which gives the museum its peculiar but potent place within disciplinarity. The museum builds knowledge over the time of a visit through dispersed, yet charted, cultural encounters set up for the imagined visitor as response-inviting structures. This is to think of museums as politicised cartographic surveys, and of visiting museums as itinerant, transhistorical and transgeographical engagement and encounter.

Disciplinarity and the museum have something important to do with one another, because the museum is the principal institutional locus for the management of socially valued objects and for theorising about their status and relationality; but as we have seen over the course of this book, this intellectual

endeavour is politically and circumstantially contingent and is highly divisive. Lastly, the role of the museum as a place of objects and of charted cultural encounters with those objects is a foundational convention whose relationship to disciplinary knowledge goes largely unquestioned. Should disciplines like archaeology and art history today be based on objects at all, or should they focus *through* objects on other things? Should objects predominate, or should practices? How do we (should we) differentiate the study of humanity from that of its material culture, or vice versa? What are the chronological and material gaps in our disciplinary understandings of history, and how, if at all, do we rationalise them? I hope that this book prompts some reflection on, or at least confusion about, the stories which museums tell and do not tell, the disciplinary stories which we tell ourselves and the disciplinary groups within which we situate ourselves.

Bibliography

Alberti, S. (2008), 'Constructing nature behind glass' in *Museum and Society* 6.2: 73-97.

Amariglio, J., Resnick, S. and Wolff, R.D. (1993), 'Division and difference in the "discipline" of economics' in E. Messer-Davidow, D.R. Shumway and D.J. Sylvan (eds), *Knowledges: Historical and Critical Studies in Disciplinarity* (University of Virginia Press), 150-84.

Bal, M. (1990), 'De-disciplining the eye', *Critical Inquiry* 16.3: 506-31.

Bal, M. (1996), *Double Exposures: The Practice of Cultural Analysis* (Routledge).

Barnes M. & Whitehead, C. (1998), 'The "suggestiveness" of Roman architecture: Henry Cole and Pietro Dovizielli's photographic survey of 1858-59', *Architectural History* 41: 192-207.

Barthes, R. (1997), *Image-Music-Text* (Hill & Wang).

Barringer, T. (1997), 'The South Kensington Museum and the Colonial Project' in Barringer, T. and Flynn, T. (eds), *Colonialism and the Object: Empire, Material Culture and the Museum* (Routledge).

Becher, T. and Trowler, P. (1989), *Academic Tribes and Territories: Intellectual Enquiry and the Cultures of Discipline* (Open University Press).

Becker, H. (1982), *Art Worlds* (University of California Press).

Becker, H. (1986), *Doing Things Together* (Northwestern University Press).

Bennett, T. (1995), *The Birth of the Museum: History, Theory, Politics* (Routledge).

Bourdieu, P. and Wacquant, L.J.D. (1992), *An Invitation to Reflexive Sociology* (University of Chicago Press).

Bourdieu, P. (1984), 'Le champ littéraire: préalables critiques et principes de méthode', *Lendemains* 36: 5-20.

Bourdieu, P. (1991), 'Le champ littéraire', *Actes de la Recherché en Sciences Sociales* 89: 4-46.

Bourdieu, P. (1993), *The Field of Cultural Production* (Polity Press).

Bibliography

Bowker, G.C., and Star, S.L (1999)., *Sorting Things Out: Classification and its Consequences* (MIT Press).

Boxer, M.J. (2000), 'Unruly knowledge: women's studies and the problem of disciplinarity', *National Women's Studies Association Journal*, 12.2: 119-29.

Caygill, M. (1997), ' "Some recollections of me when I am gone": Franks and the early medieval arachaeology of Britain and Ireland' in M. Caygill and J. Cherry (eds), *A.W. Franks: Nineteenth-Century Collecting and the British Museum* (British Museum Press), 160-83.

Chakrabarty, D. (2002), 'Museums in late democracies', *Humanities Research*, 9.1, http://www.anu.edu.au/hrc/publications/hr/issue1_2002/index.htm, accessed January 2008

Classen, C. (1993), *Worlds of Sense: Exploring the Senses in History and Across. Cultures* (Routledge).

Cole, H. (writing anonymously), *The National Gallery Difficulties Solved, at a Cost of Eighty Thousand Instead of a Million Pounds, By Retaining the Pictures of the Ancient Masters in Trafalgar Square; Removing the Schools and Exhibitions of the Royal Academy; Consolidating the Vernon and Turner with the Sheepshanks Pictures at Kensington, and Circulating Superfluous Pictures in the Provinces*, (privately printed, 1857).

Coltman, V. (2005), *Fabricating the Antique: Neoclassicism in Britain, 1760-1800* (University of Chicago Press).

Cook, B.F. (1997), 'Newton, Sir Charles Thomas (*bap.* 1816, *d.* 1894)', *Oxford Dictionary of National Biography*, Oxford University Press, 2004; online edn, http://www.oxforddnb.com/view/article/20051, accessed February 2008.

Danto, A C. (1997), *After the End of Art: Contemporary Art and the Pale of History* (Princeton University Press).

Davies, H. (1998), 'John Charles Robinson's work at the South Kensington Museum, part 1: the creation of the collection of Italian Renaissance objects at the Museum of Ornamental Art and the South Kensington Museum, 1853-62', *Journal of the History of Collections*, 10.2: 169-88.

Eastlake, C.L. (1845), 'The National Gallery: arrangement of picture galleries generally', *The Builder*, 282-4.

Eco, U. (1981), *The Role of the Reader* (Hutchinson).

Elkins, J. (2007), *Is Art History Global?* (Routledge).

Evans, C. (2007), ' "Delineating objects": nineteenth-century antiquarian culture and the project of archaeology in S. Pearce (ed.), *Visions*

Bibliography

of Antiquity: The Society of Antiquaries of London 1707-2007 (Society of Antiquaries), 267-305.

Ferguson, B.W. (1996), 'Exhibition rhetorics: material speech and utter sense' in R. Greenberg, B.W. Ferguson and S. Nairne, *Thinking About Exhibitions* (Routledge) 175-90.

Foucault, M. (1972), *The Archaeology of Knowledge* (Harper and Row).

Foucault, M. (1980), *Power / Knowledge: Selected Interviews and Other Writings, 1972-1977* (Random House).

Foucault M. (1994), *Dits et Ecrits*, vol. II (Gallimard).

Fuller, S. (1993), 'Disciplinary boundaries and the rhetoric of the social sciences' in E. Messer-Davidow, D.R. Shumway and D.J. Sylvan (eds), *Knowledges: Historical and Critical Studies in Disciplinarity* (University of Virginia Press), 125-49.

Fyfe, G., 1996, 'A Trojan horse at the Tate: theorizing the museum as agency and structure' in Fyfe, G. and Macdonald, S. (eds), *Theorizing Museums: Representing Identity and Diversity in a Changing World* (Blackwell, 1996) 203-28.

Gaehtgens, T.W. (1994), 'The Berlin museums after reunification' in *The Burlington* Magazine 136.1090: 14-20.

Gieryn, T.F. (1999), *Cultural Boundaries of Science: Credibility on the Line* (University of Chicago Press).

Gosden, C., Phillips, R. and Edwards, E. (2006), *Sensible Objects: Colonialism, Museums and Material Culture* (Berg).

Graslund, B. (1987), *The Birth of Prehistoric Chronology: Dating Methods and Dating Systems in Nineteenth-Century Scandinavian Archaeology* (Cambridge University Press).

Gregory, K. and Witcomb, A. (2007), 'Beyond nostalgia: the role of affect in generating understandings at heritage sites' in S.J. Knell, S. MacLeod and S. Watson (eds), *Museum Revolutions: How Museums Change and Are Changed* (Routledge) 263-75.

Grenfell, M. and Hardy, C. (2007), *Art Rules: Pierre Bourdieu and the Visual Arts* (Berg).

Hall, S. (ed.) (1997), *Representation: Cultural Representations and Signifying Practices* (Sage Publications).

Harley, J.B. (2002), *The New Nature of Maps: Essays in the History of Cartography* (Johns Hopkins University Press).

Haxthausen, C.W. (2002), 'Introduction' in C.W. Haxthausen (ed.), *The Two Art Histories: the Museum and the University* (Yale University Press), ix-xxv.

Heizer, R.F. (1962), 'The background of Thomsen's three-age system', *Technology and Culture* 3.3: 259-66.

Bibliography

Hill, K. (2005), *Culture and Class in English Public Museums, 1850-1914* (Ashgate).

Hitchens, C. (1987), *The Elgin Marbles: Should they be Returned to Greece?* (Chatto and Windus).

Hoeniger, C. (1999), 'The restoration of early Italian "Primitives" during the twentieth century: valuing art and its consequences', *Journal of the American Institute for Conservation* 38: 144-61.

Hoock, H. (2003), *The King's Artists: The Royal Academy of Arts and the Politics of British Culture, 1760-1840* (Clarendon Press).

Hooper-Greenhill, E. (1992), *Museums and the Shaping of Knowledge* (Routledge).

Howes, D. (2005), 'Introduction: empires of the senses' in D. Howes (ed.), *Empire of the Senses: The Sensual Culture Reader* (Berg) 1-17.

Iser, W. (1978), *The Act of Reading* (Johns Hopkins University Press).

Jenkins, I. (1992), *Archeologists and Aesthetes in the Sculpture Galleries of the British Museum* (British Museum Press).

Jewish Museum Berlin, www.juedisches-museum-berlin.de/site/EN/05-About-The-Museum/03-Libeskind-Building/04-Axes/axes.php, accessed January 2008.

Kirshenblatt-Gimblett, B. (1998), *Destination Culture: Tourism, Museums and Heritage* (University of California Press).

Knell, S.J. (ed.) (2007), *Museums in the Material World* (Routledge).

Lee, A. (2005), *Knowing Our Business: The Role of Education in the University* (monograph for the Australian Council of Deans of Education).

Lenoir, T. (1993), 'The discipline of nature and the nature of disciplines' in E. Messer-Davidow, D.R. Shumway and D.J. Sylvan (eds), *Knowledges: Historical and Critical Studies in Disciplinarity* (University of Virginia Press), 70-102.

Levi, D. (2000), 'Between fine art and manufacture: the beginnings of Italian medieval and renaissance sculpture at the South Kensington Museum' in C. Sicca and A. Yarrington (eds), *The Lustrous Trade: Material Culture and the History of Sculpture in England and Italy, c. 1700-c. 1860* (Continuum), 211-21.

Levy, M. (1962), *A Concise History of Painting from Giotto to Cezanne* (Thames and Hudson).

Lidchi, H. (1997), 'The poetics and politics of exhibiting other cultures' in S. Hall (ed.), *Representation: Cultural Representations and Signifying Practices* (Sage Publications), 151-222.

Lumley, R. (1998), 'Introduction' in R. Lumley (ed.), *The Museum*

Bibliography

Time Machine: Putting Cultures on Display (Routledge, 1998), 1-24.

Macdonald, S. (1996), 'Theorizing museums: an introduction' in G. Fyfe and S. Macdonald (eds), *Theorizing Museums: Representing Identity and Diversity in a Changing World* (Blackwell, 1996), 1-20.

MacGregor, A. (1997), 'Collectors, connoisseurs and curators in the Victorian age' in M. Caygill and J. Cherry (eds), *A.W. Franks: Nineteenth-Century Collecting and the British Museum* (British Museum Press), 6-33.

MacGregor, A. (1998), 'Antiquity inventoried: museums and "national antiquities" in the mid nineteenth century' in V. Brand (ed.), *The Study of the Past in the Victorian Age* (Oxbow Books, 1998), 125-38.

Mason, R. (2007), 'Cultural theory in Museum Studies' in S. Macdonald (ed.), *A Companion to Museum Studies* (Blackwell), 17-32.

McClellan, A. (1999), *Inventing the Louvre: Art, Politics and the Origins of the Modern Museum in Eighteenth-Century Paris* (University of California Press).

McClellan, A. (2003), 'A brief history of the art museum public' in A. McClellan (ed.), *Art and its Publics: Museum Studies at the Millennium* (Blackwell), 1-50.

McClellan, A. (2008), *The Art Museum from Boullée to Bilbao* (University of California Press).

Messer-Davidow, E., Shumway, D.R. and Sylvan, D.J. (1993), 'Introduction: disciplinary ways of knowing' in E. Messer-Davidow, D.R. Shumway and D.J. Sylvan (eds), *Knowledges: Historical and Critical Studies in Disciplinarity* (University of Virginia Press), 1-21.

Monmonier, M. (1996), *How to Lie with Maps* (Chicago University Press).

Moser, S. (2006), *Wondrous Curiosities: Ancient Egypt at the British Museum* (University of Chicago Press).

Newton, C.T. (1880), 'On the study of archaeology' in C.T. Newton, *Essays on Art and Archaeology* (Macmillan), 1-38.

Pallasmaa, J. (1816), *The Eyes of the Skin: Architecture and the Senses* (John Wiley & Sons).

Parliamentary Papers (1816), *Report from the Select Committee on the Earl of Elgin's Collection of Sculptured Marbles &c.* (House of Commons).

Parliamentary Papers (1850, *Report, Proceedings and Minutes of Evidence of the Select Committee Appointed to Consider the Present Accommodation Afforded by the National Gallery; and the Best Mode of Preserving and Exhibiting to the Public, the Works of Art*

Bibliography

Given to the Nation or Purchased by Parliamentary Grants (House of Commons).

Parliamentary Papers (1850), *Report of the Commissioners Appointed to Inquire into the Constitution and Government of British Museum with Minutes of Evidence* (House of Commons).

Parliamentary Papers (1853), *Report, Proceedings and Minutes of Evidence of the Select Committee Appointed to Inquire into the Management of the National Gallery; also to Consider in what Mode the Collective Monuments of Antiquity and Fine Art Possessed by the Nation may be most Securely Preserved, Judiciously Augmented, and Advantageously Exhibited to the Public* (House of Commons).

Parliamentary Papers (1857), *Report, Proceedings and Minutes of Evidence of the Royal Commission of 1857 on the Site for the National Gallery* (London).

Parliamentary Papers (1860), *Report from the Select Committee on the British Museum; Together with the Proceedings of the Committee, Minutes of Evidence and Appendix* (House of Commons).

Pearce, S. (1992), *Museums Objects and Collections: A Cultural Study* (Leicester University Press).

Pearce, S. (2007), 'Antiquaries and the interpretation of ancient objects, 1770-1820' in S. Pearce (ed.), *Visions of Antiquity: The Society of Antiquaries of London 1707-2007* (Society of Antiquaries), 147-71.

Pope, J.W. (2007) 'Ägypten und Aufhebung: G.W.F. Hegel, W.E.B. Du Bois, and the African Orient', *New Centennial Review* 6.3: 149-92.

Preziosi, D. (1993), 'Seeing through art history' in E. Messer-Davidow, D.R. Shumway and D.J. Sylvan (eds), *Knowledges: Historical and Critical Studies in Disciplinarity* (University of Virginia Press), 215-31.

Ravelli, L.J. (2006), *Museum Texts: Communication Frameworks* (Routledge).

Robertson, B. (2004), 'The South Kensington Museum in context: an alternative history', *Museum and Society* 2.1: 1-14.

Robertson, D. (1978), *Sir Charles Eastlake and the Victorian Art World* (Princeton University Press).

Robinson, J.C. (1862), 'On our national art museums and galleries', *The Nineteenth Century* 32.190.

Robinson, J.C. (1897), 'Our public art museums: a retrospect' in *The Nineteenth Century* 42.250.

Shapin, S. and Schaffer, S. (1985), *Leviathan and the Air Pump* (Princeton University Press,).

Bibliography

Siegel, J. (2000), *Desire and Excess: The Nineteenth-Century Culture of Art* (Princeton University Press).

Silber, I.F. (1995), 'Spaces, fields, boundaries: the rise of spatial metaphors in contemporary sociological theory', *Social Research* 62: 322-55.

Skeates, R. (2000), *Debating the Archaeological Heritage* (Duckworth).

St Clair, W. (1988), *Lord Elgin and the Marbles*, 3rd edn (Oxford University Press).

Staniszewski, M.A. (2001), *The Power of Display: A History of Exhibition Installations at the Museum of Modern Art* (MIT Press).

Steegman, J. (1987), *Victorian Taste: A Study of the Arts and Architecture from 1830 to 1870* (Century).

Storr, R. (2007), 'Show and tell' in P. Marincola (ed.), *What Makes a Great Exhibition?* (London: Reaktion Books) 14-31.

Sutton, T. (2000), *The Classification of Visual Art: A Philosophical Myth and Its History* (Cambridge University Press).

Swartz, D. (1997), *Culture and Power: The Sociology of Pierre Bourdieu* (University of Chicago Press).

Taylor, B. (1991), 'Displays of power: with Foucault in the museum', *Circa* 59: 21-7.

Taylor, B. (1999), *Art for the Nation: Exhibitions and the London Public, 1747-2001* (Manchester University Press).

Thompson Klein, J. (1993), 'Blurring, cracking, and crossing: permeation and the fracturing of disciplines' in E. Messer-Davidow, D.R. Shumway and D.J. Sylvan (eds), *Knowledges: Historical and Critical Studies in Disciplinarity* (University of Virginia Press), 185-214.

V&A Museum www.vam.ac.uk/collections/metalwork/metalwork_features/sacred_silver/judaica/13th_century_spice_box/index.html, accessed January 2008.

Wainwright, C. and Gere, C. (2002), 'The making of the South Kensington Museum I: the Government Schools of Design and founding collection, 1837-51', *Journal of the History of* Collections 14: 3-23.

Warburton, N. (2003), *The Art Question* (Routledge).

Wenger, E. (1999), *Communities of Practice: Learning, Meaning, and Identity* (Cambridge University Press).

Whitehead, C. (2000), 'Enjoyment for the thousands: sculpture display at South Kensington 1851-1862' in Sicca, C. and Yarrington, A. (eds), *The Lustrous Trade: Material Culture and the History of Sculpture in England and Italy, c. 1700-c. 1860* (Continuum), 222-39.

Whitehead, C. (2005a), *The Public Art Museum in Nineteenth-Century Britain: The Development of the National Gallery* (Ashgate).

Bibliography

Whitehead, C. (2005b), 'Architectures of display at the National Gallery: the Barry Rooms as art historiography', *Journal of the History of Collections* 17: 189-211.

Whitehead, C. (2005c), 'To display is to theorise', *Architectural Research Quarterly* 8. 3+4: 202-3.

Whitehead, C. (2006), 'Aesthetic otherness, authenticity and the roads to museological appropriation: Henry Cole's travel writing and the making of the Victoria and Albert Museum', *Studies in Travel Writing*, 10.1: 1-26.

Whitehead, C. (2007) 'Establishing the manifesto: art histories in the nineteenth century museum' in S. Knell, S. Macleod and S. Watson (eds), *Museum Revolutions: How Museums Change and Are Changed* (Routledge), 48-60.

Wilson, D.M. (2002), *The British Museum: A History* (British Museum Press).

Wilson, T.H. (1985), 'The origins of the maiolica collections of the British Museum and the Victoria and Albert Museum, 1851-55', *Faenza* 71: 68-81.

Wood, D. (1992), *The Power of Maps* (Guilford Press).

Index

Index

Index

Index

Mulready, William, 93
multimedia, 47
multi-sensory experience, 37
musealisation, 21
Museo di Castelvecchio
 (Verona), 28
museology, 20, 41, 116; New
 Museology, 19; museological
 literature, 37; museological
 practices, 40; museological
 construction of disciplines,
 40; museological action, 84;
 museological regimes, 96;
 museological proposals, 128;
 museological system, 132;
 museological discourse, 136
museum(s), 7, 8, 67, 93, 100,
 121, 127; interconnection
 with disciplines/
 disciplinarity, 8, 41;
 networks of, 10; and
 construction of knowledge,
 19; as embodied theory, 24;
 role in theorising, 25, 134;
 room types, 26, 126; walls
 (textures and colours), 28, 35;
 historicist architecture of,
 28-9; history of, 38; as 'engine
 of difference', 40;
 establishment of, 41; media
 potential of, 42; authority of,
 44; natural history, 47-8; as
 map, 48-9; development of,
 51, 77, 109; scope of, 58, 115;
 autonomy as a sub-field, 72;
 London, 73, 79, 80, 93, 101;
 domains, 78; values of, 78;
 management structures, 78,
 80; reconfiguration of, 79;
 management, 79; site of, 93;
 Pagan, 118-19, 121, 123, 128;
 Christian, 118-19, 121, 123,
 128; of Christian art, 122-3;
 ethnographical, 124;
 parameters, 125; as

politicised cartographic
 survey, 137
museum actions, 38-9, 69, 73,
 116, 133
museum architecture, 27, 100
museum critics, 46, 64, 71, 73,
 79, 92, 119
museum departments, 81, 95;
 naming of, 45; staffing of, 45
museum interpretation, 30
museum practice(s), 37, 43, 136;
 authorial characteristics of,
 38; external influence on, 39,
 72
museum representation(s), 34,
 39, 47, 80, 133; textual
 characteristics of, 38; value
 of, 56
museum studies, 12
museum world(s), 10, 45-7, 49,
 50, 52-3, 56, 59, 61, 64, 66,
 68-9, 71, 74, 79, 96, 129, 133;
 museum world's map of the
 world, 77
Museum of Manufactures (*see
 also* South Kensington
 Museum; Victoria and Albert
 Museum; Museum of
 Ornamental Art), 59, 80
Museum of Modern Art (MoMA)
 (New York), 28-9, 38
Museum of Ornamental Art (*see
 also* South Kensington
 Museum; Victoria and Albert
 Museum; Museum of
 Manufactures), 113
Museum of Practical Geology, 80
music videos, 29
mythography; Greek, 112
mythology, 21, 117; Greek, 112,
 132

Napoleon, 84; Napoleonic
 conflict, 81
narration, 40

155

Index

narrative, 10, 33, 35, 37, 40, 42, 44, 47, 107, 109; object-based, 43; of evolution of style, 68; of art, 90; historical, 106, 134
National Gallery (London), 7, 8, 28, 47, 50, 58, 68, 72, 78, 80, 92-6, 99, 100, 103, 106, 115, 118, 123, 126, 130, 134; Sainsbury Wing, 28; management of, 47, 65, 101, 118, 129; reform of, 72, 118; foundation of, 81, 119; Select Committee (of 1850) on, 93; Select Committee (of 1853) on, 93-4, 100, 102, 112, 118, 122, 130; Select Committee (of 1853) Report, 100, 103, 118; institutional identity of, 94; trustee, 101; Director, 101, 127; parameters of, 101; boundaries of, 101; purpose of, 102; collection of, 102-3, 108; displays of, 102; relations to other institutions, 102; amalgamation of collections with those of British Museum, 108, 118-19
national identity, 82; construction of, 68
National Portrait Gallery, 81
natural history, 47-8, 51, 81, 122
Natural History Museum; establishment of, 122
natural sciences, 22, 41
naturalia, 81
Neues Museum (Berlin), 28
New Hermitage (museum, St Petersburg), 100
Newton, Charles Thomas, 33, 83, 88-9, 108, 110-17, 119-20, 122-3, 125-6, 128, 133, 135; Acting Consul at Rhodes, 108; 'On the Arrangement of the Collection of Art and

Antiquities in the British Museum' (letter), 108-10, 112, 115; 'On the Study of Archaeology' (essay), 112; specific interests in religion, 112
Nile (Battle of the), 90
Nollekins, Joseph, 82
numismatics, 33, 96, 123; Roman Imperial series, 123; Byzantine series, 123

objects (*see also* boundary objects; material culture; antiquities; art (works of art)), 21, 31, 42-3, 54, 93, 100, 110, 117, 121, 124, 128, 134-5, 138; relationships between, 19, 33; engagement with, 22; collecting of, 22; analysis of, 22, 69; conservation of, 22; display of, 19, 24, 26-8, 87, 90; juxtaposition, 24-5, 32-3, 50, 94, 101; technology of juxtaposition, 38; juxtaposition of science and art objects, 114; legitimating, 25; selection of, 26-7, 29, 40, 95; ordering of, 26, 29-30, 53, 99, 103, 106; placing/placement of, 25-6, 29-30, 55, 137; bodies of, 26; provenance of, 28, 115; (de)contextualisation of, 28, 41; positioning of, 50; relation with events, 38; visitor engagement with, 31-2; characteristics, 40; preservation of, 40; restoration of, 40, 44, 87; value of, 24, 40, 51, 54, 71, 96, 120-1, 126, 136; graphic representation of, 41; roles and uses of, 43, 77, 106;

Index

ownership of, 43; decay of,
44; subjection to process of
change, 44; attribution, 44,
51; dating, 44, 117; historical,
47, 125; categorisation of, 40,
51, 54, 57, 71, 109;
mediaeval, 52-3; as
documents, 54; of
Renaissance, 54; subjugation
of, 57; acquisition of, 61, 64,
66, 73, 81-2, 106; in forming
knowledges, 62; of study, 64,
67-8, 73, 89, 112, 117, 135;
rationalisation of, 78;
transferral of, 95, 108; merit
of, 109; 'meaning and motive'
of, 110; admission into
collections, 111; age of, 115;
history of, 120; contested,
123; ethnographic, 124-6;
magical, 132; human-made,
135; transcendental, 136;
status of, 137
Oldfield, Edmund, 96-7, 116,
125

painted glass, 103
painting(s), 29, 50, 65, 72, 81,
88, 94-6, 99, 100, 102-3, 113,
117, 119, 121, 123, 126, 128,
130, 132, 135; of
Renaissance, 7, 28, 50;
mediaeval, 29, 66, 99, 106;
easel paintings, 58; historical
painting, 65, 132;
portraiture, 65, 81; landscape
painting, 65; genre painting,
65; consecrated, 99;
canonised, 99; quality, 106;
Early Italian, 106; religious,
111, 120; arrangement of,
117; as discrete category of
material culture, 127, 129,
135; integration into wider
museum collections, 129,

134; political investment in,
129; as objects of social use,
136
Pallasmaa, Juhani, 37
Panizzi, Antonio, 53, 59, 119,
122, 125, 133
parks (public), 66
Parliament, 118; parliamentary
debates, 92, 102;
parliamentary papers, 79
Parthenon, 87-8, 110; frieze, 83,
88
Parthenon marbles (see also
Elgin (Lord)), 12, 77, 82-6,
88-9, 96-8; value of, 82, 88;
Select Committee on, 82-3,
87; consecration of, 83;
classification (as art), 83-5,
87-9; influence on
contemporary art, 86; display
of, 87; values ascribed to, 88;
study of, 88-9
patron(s), 29, 118
patronage, 68
Pausanias, 110
Payne Knight, Richard, 83
Pearce, Susan M., 23, 44
Peel, Sir Robert, 79, 93
Pericles, 85
period rooms, 29
periodisation, 30, 67
permeation, 39, 61, 65-9, 72, 74,
84, 130; of museum practices
with political imperatives,
72, 133
personal effects, 29
Pheidias (Phidias), 83, 85, 88-9,
112
Phillips, Ruth B., 37
photographs, 31
Phrenological Museum (Strand),
80
Plan for a Collection of
Paintings, Illustrative of the
History of Art (Ralph

157

Index

Lightning Source UK Ltd.
Milton Keynes UK
UKHW021421151119
353603UK00007B/423/P